A GUIDE TO HISTORIC
Staunton
VIRGINIA

EDMUND D. POTTER

Charleston London

THE
History
PRESS

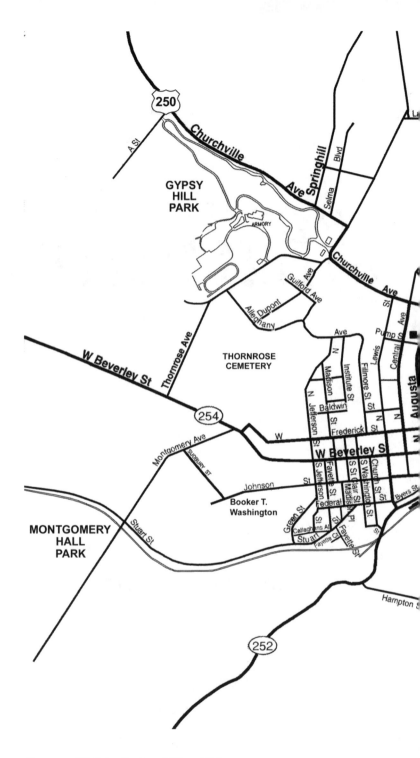

Staunton, Virginia. *Courtesy of Edmund Potter.*

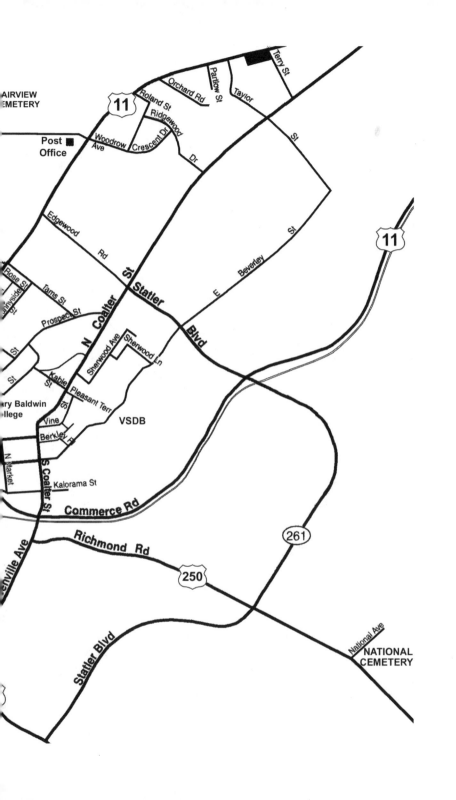

Published by The History Press
Charleston, SC 29403
www.historypress.net

All photos by the author unless otherwise noted.

First published 2008

Manufactured in the United States

ISBN 978.1.59629.543.8

Library of Congress Cataloging-in-Publication Data

Potter, Edmund D.
A guide to historic Staunton / Edmund D. Potter.
p. cm.
ISBN 978-1-59629-543-8
1. Staunton (Va.)--History. 2. Staunton (Va.)--Description and travel. 3. Staunton
(Va.)--Buildings, structures, etc. 4. Historic buildings--Virginia--Staunton. I.
Title.
F234.S8P67 2008
975.5'911--dc22

2008034257

Notice: The information in this book is true and complete to the best of our
knowledge. It is offered without guarantee on the part of the author or The History
Press. The author and The History Press disclaim all liability in connection with
the use of this book.

Contents

Acknowledgements

To truly understand Staunton history you need to be a native. I am a recent immigrant and as such I have had to rely on the help of many to put this project together. The creation of this book would not have been possible without the help of Frank Strassler, Vickie Einselen and the staff of the Historic Staunton Foundation; Dr. Douglas Harmon, Betty Lewandowski and the staff of the Augusta County Historical Society; Richard Hamrick and the Hamrick Photographic Archives; and the Chesapeake and Ohio Railroad Historical Society. I also owe a tremendous debt to the work of Dr. Katharine Brown, Dr. Kenneth Keller, Dr. Amy Tillerson, Dr. Catherine Zipf, Francisco B. Newman Sr., Elizabeth McCue, Lyman Chalkley, Joe Nutt, Charles Culbertson, Sue Simmons and especially Joseph Waddell. Dr. Ruth Chodrow, Thelma Newman, Stephen Wilts, Rick Chittum, Nancy Sorrells, Ginger Carter, Lucinda Cooke, Clifton and Dorothy Potter and many others who were key in helping me unearth important facts about Staunton's past. Finally, special thanks go to my wife Rachel and my two boys Eric and Landon, who helped with the long hours of research and writing.

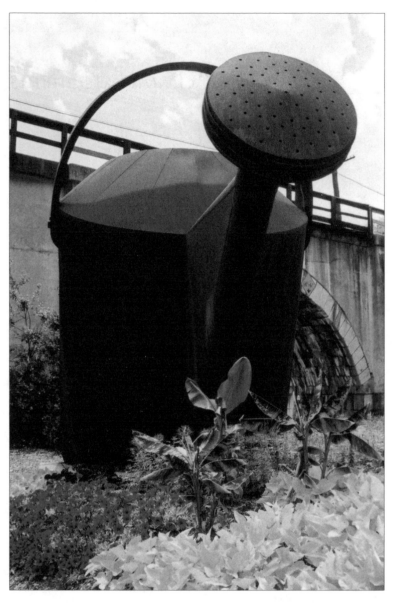

One of the icons of Staunton that greets visitors is this giant watering can designed by Willie Ferguson in the 1990s. Some of Ferguson's other work includes a plow by the stockyards on Statler Boulevard and a book at the Public Library.

Introduction

S taunton is a city that seems to defy logic. It has all the comforts of a modern automobile-based economy. There are suburbs and "big box" stores, and yet it also has a vibrant downtown with some 260 different businesses, artists' galleries and multiple cultural and historic destinations. How has Staunton, or as the locals pronounce it "Stanton," done it? The truth is that success has not come easily nor is the work ever done. From the start, surrounding Augusta County was a rural area with citizens who valued education. While many cities focused on attracting one industry in the late nineteenth and early twentieth centuries, Staunton was content to act as a middleman and foster small business. After World War II, leaders in the community appeared to turn their backs on their architectural heritage. Luckily, there were citizens in Staunton who were not prepared to accept the destruction of two hundred years of history, and that has made all the difference.

In dealing with an old structure, there are several options. First, you can remove it and start anew. The problem with this is that the quality of antique craftsmanship can be hard to find these days. The second choice is to stabilize and then maybe restore it to a set time period. This is great for capturing a moment in time but difficult to maintain in the long run. The last option is adaptive reuse. This recognizes that times and people change, but we can still appreciate

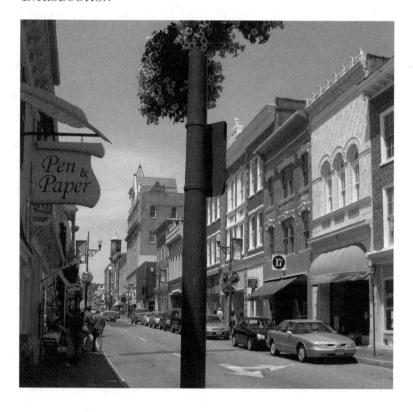

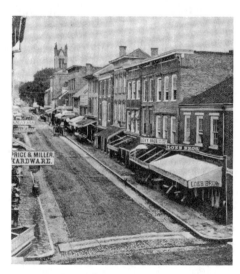

Above: Downtown Staunton looking west from New Street today.

Left: Downtown Staunton from the same corner in 1880. The second and third buildings from the corner of New Street have not changed, but little else of the block except the structure at the junction of Beverley and Augusta remains. The steeple belonged to the Lutheran church, which was replaced by the Clock Tower Building. *Courtesy of the Hamrick Archives.*

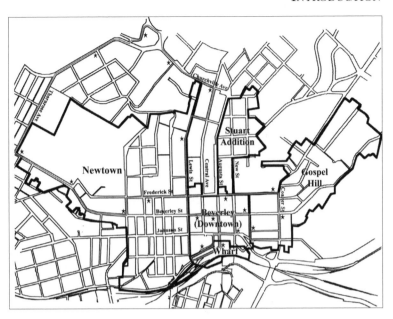

Staunton has a population of less than twenty-four thousand, but it has five historic districts and a true commitment to preserving and celebrating its history. The gray line is the route taken by the Staunton Trolley. Service is free and runs every half hour, Monday through Saturday, 10:00 a.m. until 10:00 p.m. From January through April it runs 10:00 a.m. to 6:00 p.m. Stops are marked by a star. *Courtesy of the author.*

the past. As an example, a factory can become a series of artists' studios. This is in effect what Staunton has done. Residents have saved much of the character of their downtown while adapting it to the needs of the present and hopefully the future.

Architectural Terms

To make your reading of this visitors' guide more useful as you travel around Staunton, here are some defined architectural terms for your reference.

Arts and Crafts: This type of design developed in the late nineteenth century in an attempt to save handcrafted workmanship, which was being replaced by machine-made products. It also rejected the excess of Victorian architecture for simple forms and often dark woodwork.

Beaux-Arts: This term refers to the French architectural academy, the École des Beaux-Arts. This style of heavily classically inspired architecture took off after the Chicago World's Fair of 1893. Americans took Roman architecture and added some modern decoration. This style of architecture reflects the growth of America as a world power and is best exemplified by many of the Federal buildings built in Washington, D.C., after 1903.

Chateauesque: Chateauesque refers to the early Renaissance castles of France, which mixed medieval design with classical forms. Another way of considering it, Chateauesque is a less decorative form of the Queen Anne style with classical columns.

Colonial Revival: The Colonial Revival began at the end of the nineteenth century, but it lasted well into the 1960s. Early versions of this style were inspired by New England homes with wood siding

and little or no ornament. In Virginia, many Colonial Revival homes were brick and often looked back to Jeffersonian ideas of design. Following the creation of Colonial Williamsburg in 1928, there was an explosion of this style throughout the Commonwealth.

Federal: The Federal style refers to a style of architectural design popular in the late eighteenth and early nineteenth centuries. Buildings are usually simple squares or rectangles with very little ornament on the outside, the exception being a classically inspired porch and a central fan window. Balance is important in Federal architecture.

Gothic Revival: Gothic Revival architecture became popular with church construction in the 1840s but it quickly spread to many other types of buildings. Medieval cathedrals and castles inspire this style. Asymmetry in design, pointed arches and stylized ornament are key elements of this type of architecture.

Greek Revival: The Greek Revival style became popular, especially in the South, in the 1830s and 1840s. It is classically inspired like Jeffersonian, but instead of looking to the Romans, who liked more ornament, this style employed the simpler forms of the Greeks. Also, there are no arches or fan windows in this form of architecture.

Italianate: Italianate architecture was inspired by rural buildings in the north of Italy. Italianate structures often have roofs with overhanging eaves and decorative brackets. This style was popular in the ten years before the Civil War.

Jeffersonian: Thomas Jefferson lived fewer than fifty miles from Staunton and thus had an effect on its architecture. Jefferson loved Roman design, with columns topped by a gabled pediment. He also regularly employed lattice or Chinese Chippendale railings. Finally, America's third president did not hide the native red brick, but instead liked to contrast it with the columns and railings.

Queen Anne: The Queen Anne style refers generally to large Victorian homes that are asymmetrical and have one or more towers, none of which are the same size.

Richardson Romanesque: This term refers to the style developed by Henry Hobson Richardson. Richardson was one of the first American architects to formally study architecture in

France. Rather than just copying an earlier style, he tried to create a new type of design inspired by early medieval buildings, which utilized a rounded Roman, rather than pointed Gothic, arch. Richardson died in 1886, but his style lasted until the end of the nineteenth century.

Second Empire: The Second Empire style refers to the architecture of Napoleon III, who ruled France from 1852 until 1870. This style often integrates classical columns, but the most distinctive feature is the mansard or double-pitch roof. It starts at a low angle and then suddenly drops off steeply. Most classic "haunted houses" are Second Empire structures.

Shingled: Shingled style is basically a house that has wooden shingles on the façade or front of the house in addition to the roof. These homes became popular in the 1880s.

Spanish Revival: Spanish Revival homes are often stucco, painted an earth tone and may have some simplified classical columns. They seek to capture a mixture of Spanish culture and native adobe mud brick.

Stick: Stick style homes are wooden structures that are asymmetrical with high-pitched roofs and gable ends. Often there are vertical beams along the side of the house to suggest the interior structure, thus the name Stick style. These homes began to appear in the late 1860s.

Tudor Revival: Tudor Revival architecture is often confused with Arts and Crafts design. While the former may incorporate exposed wooden beams on the exterior, this is integral to the overall design. By contrast, Tudor Revival uses the patterns of exposed beams with white stucco as merely a decorative element.

Crossroads
of the Valley

No matter from which direction you come to get to Staunton, you cannot help but be struck by the landscape. If you are driving from the south, the Shenandoah Valley slopes down toward Pennsylvania, or from the north, traveling up the valley toward Roanoke, Virginia, there are times when you seem almost surrounded by mountains. Coming from east or west you get to experience the mountains directly. Staunton is a crossroads for all these paths. This is why it was settled and why it continues to succeed.

Native Americans were the first to settle in Augusta County. Unfortunately, they left very little of their presence that has not been washed away by over 250 years of European settlement. Modern archaeologists have found several burial sites: in Waynesboro, on Lewis Creek below Staunton, on the Middle River close to Dudley's Mill and about five miles west of Staunton. Additionally, the Native Americans left a hunting trail that runs through the valley between the Blue Ridge and Appalachian Mountains, which we today refer to as Route 11.

John Lederer was the first explorer of the Shenandoah Valley to document the area. Governor William Berkeley sent him into the Virginia wilderness three times between 1669 and 1670. Lederer was a German who hoped to open a fur trading business. He kept notes in Latin, which were later translated by Lord Baltimore's

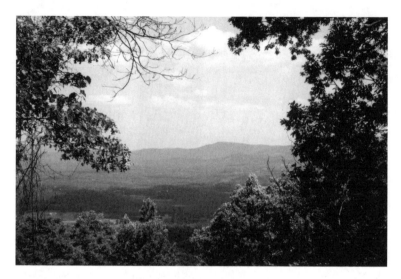

During much of the seventeenth and eighteenth centuries, the Blue Ridge Mountains hindered direct access to the Shenandoah Valley from eastern Virginia. Most people traveled up into the valley from the Philadelphia region.

secretary. On his first trip in March 1669, Lederer and three Native American guides made it to the top of the Blue Ridge Mountains. He was discouraged to see a second set of mountains, which appeared to be higher than the ones they had just climbed. Even more frustrating, he could not find a path to the valley below.

By the beginning of the eighteenth century, the English controlled the coast from South Carolina to Maine, but the French held Canada and Louisiana. While the English laid direct claim to land through settlement, the French relied heavily on missionaries and trappers to make alliances with local tribes. Governor Alexander Spotswood became convinced that it was only a matter of time before the French connected their territories through the Ohio River Valley. If England were to thwart this territorial move, Virginians need to step forward to find a path into the Shenandoah Valley and settle it. In late August 1716, the governor headed west with sixty of his men. According to John Fontaine, they arrived at the base of the Blue Ridge Mountains on September 5. The next day, Spotswood and his men found what is today known as Swift Run Gap. They

descended into the valley on an Indian trail and there found a river that they named the Euphrates. The group of adventurers then proceeded to get very drunk. They headed back to Williamsburg the next morning and Spotswood made them all Knights of the Golden Horseshoe.

While Spotswood was correct to worry about the French, he entered the valley from the wrong direction. Most early settlers came from Pennsylvania and Philadelphia rather than from Williamsburg. Germans from the Palatinate settled in the northern valley. The Quakers, Moravians and Mennonites headed south. The Scotch-Irish from Ulster and the English settled all over. Nineteenth-century historians made much of dominance by the Scotch-Irish, but more modern scholarship seems to suggest that when you combine English and German populations in the Shenandoah Valley, they were more than equal to their Ulster neighbors.

The story of Staunton's founder is a common one among both the Scots and the Irish. John Lewis was possibly a descendant of French Huguenots who had fled France for Ireland in 1685. We do know that

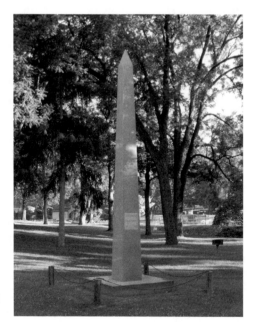

The John Lewis Memorial in Gypsy Hill Park.

his ancestors supported William III against the Catholics and were well rewarded. He married Margaret Lynn and they leased a good farm in Northern Ireland until their landlord died. When the new lord threatened to evict Lewis, Lewis killed him and then was forced to flee to Pennsylvania in 1728 to start a new life. Once he was established, Lewis brought his wife over from Ireland two years later. He began moving down the valley, and by 1732 he had finally settled in what was then referred to as Belfont. He then built Fort Lewis, a stone structure that is roughly two miles east of present-day Staunton.

In 1736, William Beverley, a wealthy planter and merchant from Essex County, Virginia, acquired a land grant of 118,491 acres "between the great mountains, on the river Sherando" from Lieutenant Governor William Gooch. At the time, the property was located in Orange County, which had only been created two years before. In the center of his land, Beverley constructed a building he called Mill Place. He also discovered that there were already people living on his land, including John Lewis.

In the four years since Lewis had arrived, roughly sixty families had established farms on what was now Beverley's land. Recognizing that on the frontier there was safety in numbers, Beverley quickly sold each farmer title to the land he was working. The Englishman recognized a money-making venture. He hired a sea captain named James Patton, who was Lewis's cousin, and then sent him to Ireland to recruit new settlers. Within two years, the population had grown enough that the House of Burgesses voted to create two new jurisdictions out of the western portion of Orange County. Frederick County would be named after the prince of Wales, who died before coming to the throne, and Augusta for his wife. Augusta County remained under Orange County's jurisdiction until it had a large enough population to be self-supporting.

At the same time that Virginia's government in Williamsburg created the parameters for the county, they also established Augusta Parish. The idea was that where the king's law could reach so too should the Church of England. Traditionally, the Scots and the Church of England had not gotten along. Conflicts over the introduction of an English Prayer Book in the 1630s in part led to the English Civil War. Many Scots fled to Ireland to be able to

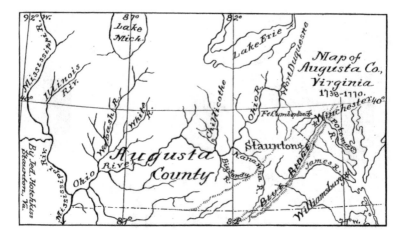

When Augusta County was first formed, it reached all the way to the Mississippi River and north through Ohio to Michigan. Thus, when war broke out with both the French and Indians in the 1750s, it was a problem for the people in Staunton. *Courtesy of Historic Staunton Foundation.*

practice their Presbyterian faith. Most of the residents of Augusta County in 1740 were not Anglicans, but it appears they were willing to accept Britain's official faith. It would seem that on the frontier any church was better than no church at all.

By 1745, there were so many people from Ulster living on or around William Beverley's manor that it was commonly referred to as the Irish Tract. On December 9 of that year, the county government was formally organized with John Lewis's son, Thomas, acting as county surveyor and Captain Patton as sheriff. As a token of goodwill, Beverley gave two acres for the county seat. He had already built a log structure on the site, which he also gave to the community as a courthouse. On July 16 of the following year, Beverley decided to set aside twenty-six additional acres to the east for the village of Augusta Courthouse. The small spot in the center of the Shenandoah Valley was now administered territory, which included most of western Virginia, Kentucky, Ohio, Indiana, Illinois and parts of western Pennsylvania.

In 1747, Thomas Lewis created thirteen half-acre lots. Within a year he had to add an additional thirty-one lots. The streets were

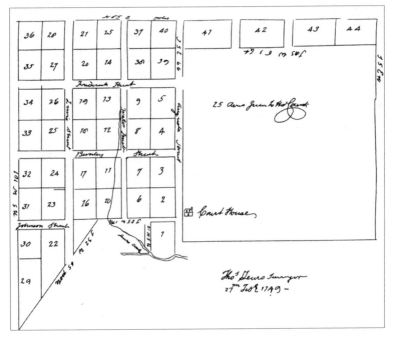

This was the map William Beverley had recorded at the courthouse on February 27, 1749, showing the original layout of Staunton. *Courtesy of Historic Staunton Foundation.*

now named Beverley, Frederick and Johnson running east to west and Augusta, Water and Lewis running north to south. On April 21, 1749, the community was officially christened Staunton in honor of Lady Rebecca Staunton, wife of William Gooch, who was governor in all but title. A rough road was also built to link the village with the Indian path six miles east that ran through the valley. This quickly became known as the Great Philadelphia Wagon Road. In 1755, William Beverley's first courthouse was turned into a home and a better log structure was built. In the midst of this development, war broke out with both the French and their Indian allies.

About the time that Thomas Lewis was finishing the layout of the town, George Croghan built a fort he called Pickawillany near what is today Pittsburgh, Pennsylvania. After four years, in 1752 he was attacked and killed by the French. The government in Philadelphia

appeared unwilling to address the matter, but not so the Virginians. They viewed this land as their own. A young George Washington was dispatched north, where he blundered into the French at Fort Necessity.

John Lewis had always had good interactions with Indians during his time in the Staunton region. According to nineteenth-century historian Joseph Waddell, an incident took place in June 1754 that changed this relationship. A group of twelve Northwestern Indians stopped at John Lewis's place on their way home. They were returning from settling a score with the Cherokee. Some neighbors who had lost relatives to Indian attacks induced the warriors to stay for the night. Once they were drunk, the locals attacked. Only one escaped alive. The incident only inflamed rising tensions. After General Braddock was defeated at Fort Duquesne the following year, there was open warfare on the frontier. Local Presbyterian minister, the Reverend John Craig, reported that people began to leave the area and head back across the Blue Ridge Mountains for safety. One of the many individuals who died early in the conflict was Captain Patton, who was killed by Native Americans at Draper's Meadow in the summer of 1755. Draper's Meadow is now part of the campus of Virginia Tech in Blacksburg.

John Lewis's sons, Andrew and Charles, both fought in the French and Indian War. The closest the conflict came to Staunton was at Keller Fort, near present-day Churchville, where the last Indian massacre in Augusta County took place in the early 1760s. Staunton was officially incorporated as a town in 1761 and the year the war ended, Augusta Parish Church opened. Britain had won, but at a high price for Staunton. As part of the treaty, the English agreed not to allow their colonists to move past the Appalachian Mountains. Most locals ignored this, but it did hurt the trade with settlers moving west.

Staunton and Augusta County embraced the American Revolution willingly. Citizens were frustrated by British rules, which hampered their commerce, and the lack of religious freedom. They were, however, far enough away from the conflict that only in June 1781 did the war directly affect them. For that month, Staunton served as Virginia's capital. Otherwise, Augusta County was considered loyal and quiet enough that Congress sent Hessian

This image from the latter part of the nineteenth century captures what many of the early structures in the Staunton area must have looked like. To gauge how much has changed, this picture was taken roughly where Interstate 81 and Route 250 meet. *Courtesy of the Hamrick Archives.*

prisoners, captured at the Battle of Trenton, New Jersey, here for safekeeping. In 1778, Thomas Lewis was part of a group sent to negotiate with the Delaware Indians to keep them out of the war. The town had a number of small factories producing war materials and met its quotas for volunteers to fight for the Revolution.

In 1797, the enlightened French noble Francois, duc de la Rochefoucauld, passed through Staunton on his tour of the United States. He described the town as being a community of about eight hundred with eight inns and fifteen to eighteen stores. Most of the buildings were at least partially stone. There was a market, a newspaper, one church and another under construction. Now that the frontier was open, the majority of the people he met were passing through on their way west. The locals appeared to be mostly interested in gambling and horse races. Most goods came up the valley from Baltimore and Philadelphia. Another visitor, Isaac Weld Jr., complained that the town was filled with lawyers, but few people were ever actually hanged.

There is very little left of this part of Staunton's history. Only two eighteenth-century buildings exist in any form within the core

Robert Finley built the first structure at 3–7 South New Street by 1760. Over the past one hundred years, it has been a grocery, laundry, tailor's shop, taxi garage and a dress shop.

of the downtown. The first is located at 3–7 South New Street. This site was originally part of the land William Beverley kept for himself. He sold it to Robert Finley, who had built a structure with a stone foundation on the land by the 1760s. Sometime at the end of the eighteenth century that building burned. In 1829, the present stone structure was built on its foundations. The brick façade you see today was added sometime before the Civil War. The other structure is located at 213–215 North Augusta Street. When it was built at the end of the eighteenth century, this tavern was on the edge of town. The structure is made of hand-hewn clapboard and board batten over logs.

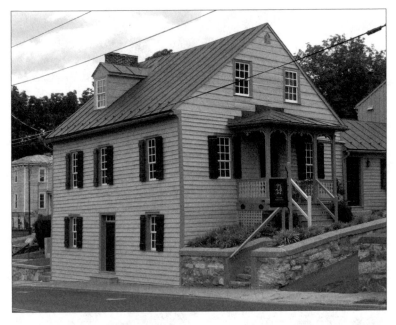

The structure at 213–215 North Augusta is made of hand-hewn clapboard and board batten over log. It was originally a tavern and later a stagecoach stop when the Valley Turnpike opened.

Was Staunton really something out of a Wild West movie, as Rochefoucauld's description implies? In 1786, Staunton Lodge 13 became the first Masonic lodge to be chartered in Virginia after the Revolution. The next year, merchant Alexander St. Clair almost doubled the size of the community by giving the town twenty-five acres west of Augusta Parish for a residential development. A new two-story stone courthouse was completed in 1789 and the following year citizens organized the first volunteer fire department in the state. There was a boys' academy, a post office and, by the turn of the nineteenth century, rules. You could not smoke your pipe or a cigar on the street, an alley or a stable due to the recognized risk of fire. Dogs, ducks and geese were also not allowed to roam freely. The town even had an ordinance on outhouses.

Newtown

The years immediately after the American Revolution were a time of promise and excitement for both the nation and Staunton. Not only had American won its independence, but the British restriction on crossing the Appalachian Mountains was also gone and the frontier could expand. As Staunton was a stop on the way west for settlers, the town expected to profit thereby.

A lot of this fervor was encapsulated in Staunton's first residential development: Newtown. The idea for the neighborhood came from Alexander St. Clair. Originally from Pennsylvania, St. Clair arrived in Staunton in 1771. By the end of the Revolution, he had acquired a fair amount of land west of the city and was living in the old courthouse, which had been moved when a better log structure was built in 1755. In 1787, he proposed to deed twenty-five acres to Staunton to be divided into forty-two lots. The town accepted and on November 6 the transfer of land was approved by the Virginia General Assembly. While generous to the community, St. Clair did keep the largest lot, in the center of Newtown, for himself.

Newtown takes its name simply from the fact that is was the newer section of Staunton. Luckily, the names of streets within the development are a bit more interesting. Moving north to south, both Beverley and Johnson Streets were to be extended. Originally Johnson was actually Johnston for Zachariah Johnston, the captain of the Augusta County Militia who had fought at the Battle of the

The original map of Alexander St. Clair's development known as Newtown. It was created by an act of the general assembly on November 6, 1787. It measured twenty-five acres and St. Clair reserved the largest lot of two acres for himself. *Courtesy of Historic Staunton Foundation.*

West Fork of the Monongahela River (now in West Virginia) in 1779 and the Battle of Richmond in 1781. He had served in the House of Delegates and had promoted both Thomas Jefferson's Virginia Statute of Religious Freedom and the ratification of the Constitution. The next street was Federal, which reflected St. Clair's views on the then-heated debate going on throughout the country as to whether America should adopt the federal Constitution or stick with the Articles of Confederation. The final street was Montgomery, named for Richard Montgomery, a brigadier general who had been one of the first patriotic heroes to die. He was killed at the Battle of Quebec in 1775. Unfortunately, the land did not quite conform to St. Clair's plan. Montgomery was truncated and the name was eventually changed to Stuart in honor of Judge Archibald Stuart.

Looking east to west, the first street was named Church because the new road ran right past Augusta Parish Church. Next came Washington, who at that time was simply a great military hero, a great Virginian and promoter of the Constitution. St. Clair Street was supposedly named for Revolutionary General Arthur St. Clair, but everyone in town knew that it was really for the former landowner. Madison was for James Madison, who many Virginians credited with having written the Constitution. Fayette Street was for the Marquis de Lafayette, who in America's darkest hour had shown that we had an ally in France. Finally, the westernmost street was named for Nathaniel Greene, who served under Washington at the early victory at Trenton in 1776 and then led the successful Southern campaign in 1780, which eventually drove Cornwallis to Yorktown. Thomas Jefferson may have been omitted in part because he was minister to France during the debate over the Constitution. His connection with Staunton, however, led all but the southernmost block of Greene Street to be renamed in the third president's honor.

It is best to begin any tour of Newtown by looking at the one thing that preceded it: Trinity Church. When Augusta County was formally organized, Governor William Gooch ordered that the sheriff hold an election for the vestry for the new parish. This would be a group of twelve men to oversee the new church and its development. From the beginning there was a problem: there were

not enough members of the Church of England in the community. As a result, eight members were actually Presbyterians. Likewise, they could not find a qualified minister so they elected to send a local Presbyterian minister, John Hindman, off to England to be ordained by the Bishop of London. William Beverley sold the present two-acre lot to the parish in 1749, but people of Staunton did not get around to building a church until 1760. That year, the vestry contracted with Francis Smith from Hanover County to build a simple forty- by twenty-five-foot brick building.

When the American Revolution came, the church was placed in a difficult position. While its members were good Americans, the church itself was seen by many of its Presbyterian neighbors as a symbol of British rule, which had oppressed them. The congregation's chance came to prove itself in June 1781. When Thomas Jefferson had become governor of Virginia, he had the state capital moved from Williamsburg inland to Richmond for safety. In May of 1781, the British overran Richmond and the general assembly was forced to flee to Charlottesville and Jefferson's home. In early June, word came that Colonel Banastre Tarleton

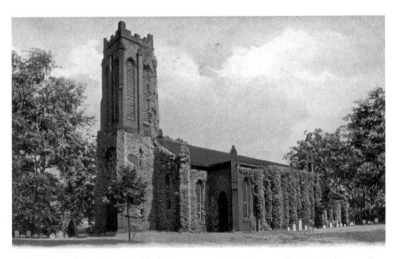

Except for the ivy, Trinity Church has changed little since this picture was taken in 1908. The structure took this final form after side aisles were added to the 1857 structure shortly after the Civil War. *Postcard from the collection of the author.*

was on his way to capture them. The state officials then fled to Staunton, where they met at Augusta Parish from June 7 to 23. While they were here, members of the general assembly elected Thomas Nelson as governor. On June 23, word reached them that the British planned to move into the valley and members dispersed back to their homes. Tarleton had in fact left Charlottesville on June 4, but not to attack Staunton. Instead he returned to Yorktown to support Cornwallis's failed defense. Today, the church still has a chair from that historic session.

It took a number of years for the new Episcopal Church to find its place in America. Bishops in England tried to make new priests swear allegiance to George III, which they refused to do. Finally, Scottish bishops went around the Church of England and helped the struggling church. In Staunton, the congregation was so desperate that in 1811, Archibald Stuart and John Howe Peyton convinced Methodist preacher William King to become an Episcopalian and be ordained by Bishop James Madison, cousin of the president.

The church began to grow and by 1830 the members of the congregation needed a new building. This structure only lasted twenty-three years before it was replace by the present Gothic Revival structure. English architect James W. Johns designed it and the cornerstone was laid on May 2, 1854. By the time it was consecrated, the structure had cost $15,000 to build. During the Civil War, the Virginia Theological Seminary was moved from Alexandria to Staunton and used Trinity. In 1869, Walter Hullihen became rector and began another building program that included a rectory for the priest to live in and side aisles to the church, and in 1874 they built Virginia's first parish house. Hullihen also oversaw the extension of the chancel, a split within the congregation, which will be discussed later, and the installation of the first of a total of twelve windows designed by the famous firm of Louis Comfort Tiffany. For much of the twentieth century, little changed at Trinity until the church was renovated in the late 1990s to accommodate a new organ designed by the local firm of Taylor and Boody. The church is open for tours most days after 1:00 p.m.

Moving into the neighborhood proper, you will see a wide variety of homes that date from the late eighteenth century to the latter

The Stuart law office was built around 1785 and was the family's first home and the first building in Newtown. *Courtesy of Historic Staunton Foundation.*

part of the nineteenth. The oldest documented structure is located on the property of 120 Church Street. Archibald Stuart was the first person to purchase a lot in the new development and this land has been owned by his family ever since. The small wooden structure with a gambrel roof on the right of the property was built for Stuart in 1785, while his larger home was in the planning stages. When the latter was completed in 1791, he turned this house into his law office. It was restored in 1975.

Stuart studied with Thomas Jefferson in 1782–83 and several decades ago some of our third president's books were found in the attic. After the British burned Washington, D.C., during the War of 1812, Jefferson sold his library to the government to help rebuild the Library of Congress. The family gave these books to

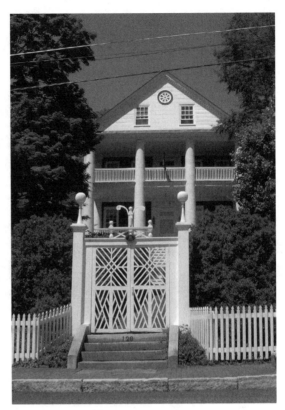

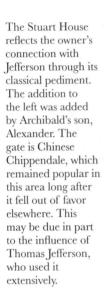

The Stuart House reflects the owner's connection with Jefferson through its classical pediment. The addition to the left was added by Archibald's son, Alexander. The gate is Chinese Chippendale, which remained popular in this area long after it fell out of favor elsewhere. This may be due in part to the influence of Thomas Jefferson, who used it extensively.

Monticello. There is a local story that Jefferson gave Stuart house plans as a wedding present. While this is doubtful, his architectural presence can be seen in the temple-like pediment, Chinese Chippendale railings, white columns and red brick. This is one of the earliest Classical Revival structures west of the Blue Ridge Mountains. Stuart was an elector for the Electoral College (which picks the president), a judge and also served as a commissioner in determining the state line between Virginia and the newly formed state of Kentucky.

His son, Alexander H.H. Stuart, studied law at the University of Virginia and went on to become a U.S. congressman and secretary of the interior under President Millard Fillmore. When Virginians began to debate leaving the Union, he was a leader in the anti-

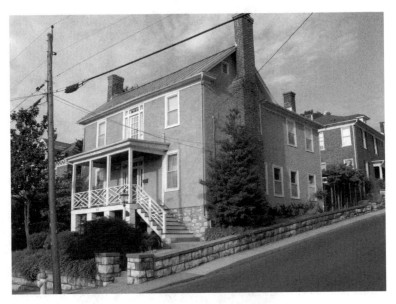

There is speculation that James Lyle's house at 102 South Washington Street may actually predate the Newtown development.

secession movement. Alexander also oversaw a major renovation of the family home. In 1844, he doubled the size of the house and became one of the first people in Staunton to have a metal roof. The work was done by Thomas Blackburn, who had studied under Jefferson at the University of Virginia. About the same time, Stuart removed all of the outbuildings from the property except for the smokehouse and the law office.

Move back to Johnson Street and head up the hill one block to 102 South Washington Street. Looking up, you will see the James Lyle Jr. House. This is an early Federal-style wood-framed structure. It was stuccoed in the early twentieth century. Lyle was one of the first three landowners in the new development. Based on research done on this dwelling, there is speculation that it may have already been on the property when Lyle bought it. He died in 1793.

Roughly a decade after Lyle's death, Staunton began to blossom as a center of government and business. In 1802, the town held its first election for a council of twelve aldermen. The first mayor

Up until the passage of the Federal Reserve Act in 1913, banks could print their own money based on the value of their holdings. Paper money was, however, only as valued as the reputation of the bank. Branches in nearby cities helped the flow of cash. This bill was printed right before America slipped into a recession sparked in part by a lack of confidence in such notes. *Courtesy of Michael Townes.*

was Jacob Swoope, for whom the area to the west of the city is named. In 1816 and again in 1825, Staunton hosted delegations from the western areas of Virginia that met to complain about their underrepresentation in the state government in Richmond. This is still a regular complaint made today. In addition to dissent, Staunton produced paper, iron, pottery, linseed oil, beer, spirits, both wool and linen textiles and served as a livestock center. This amount of commerce led Winchester's Bank of the Valley to open a branch in Staunton in 1836, giving the town its first bank. All this was possible because by 1840 the town was the junction for the Staunton and James River Turnpike running east, the Parkersburg Turnpike headed west through Buffalo Gap and the Valley Turnpike (now Route 11) headed north.

Walk two more blocks to the crest of the hill and Madison Place. This was originally the center of St. Clair's property, but it was subdivided around 1900. The George M. Cochran House at 12 Madison Place looks like a stately home equal to that built by Stuart. You would not be surprised to know that it was built in 1850. While it started life as a Greek Revival structure, it has changed greatly since. For one thing, there was a large portico that faced the city, not Johnson Street. Union General Hunter is supposed to have

Just looking at the George M. Cochran House at 12 Madison Place, you would have no idea that the appearance of this "stately home" largely reflects the influence of an early twentieth-century architect.

used this home as his headquarters when he occupied the town during the Civil War. In 1870, the Cochrans sold the building to the Wesleyan Female Institute for $25,000. The school tore down the portico and rearranged the building to face Johnson Street. In 1893, the Methodists opened Randolph Macon Woman's College in Lynchburg, Virginia. The Staunton finishing school could not compete with a four-year college of the same denomination so nearby, and within six years it closed. Newton C. Watts, the man who started the local telephone company, purchased the building. In 1919, he sold it to the Loth family, who hired Richmond Colonial Revival architect W. Duncan Lee to "restore" the building to its present condition.

Another set of structures related to a failed school can be found at the southern end of Fayette Street. Numbers 212 and 208 were at one time wings of the Staunton Female Seminary. They are

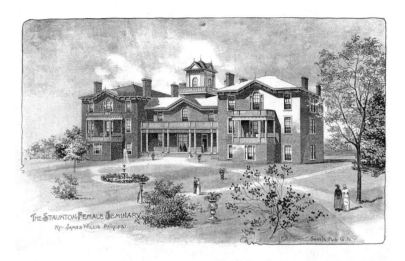

The Staunton Female Seminary as it looked in 1890. *Courtesy of the Hamrick Archives.*

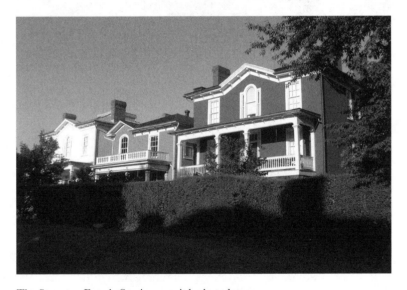

The Staunton Female Seminary as it looks today.

The Hugh McDowell House on 19 Fayette Street is a mixture of an eighteenth-century wood structure, a mid-nineteenth-century brick building and a T.J. Collins arch.

both Italianate structures built in 1872. The Lutheran boarding school was run by Joseph Miller, a Lutheran minister who during the Civil War preached to a Union congregation in Maryland and a Confederate church in Harpers Ferry. He moved to Staunton in 1866 and ran the school from 1870 until 1882. The school began to have financial trouble in 1894 and was sold four years later. The school's land was divided into eleven lots at the turn of the twentieth century. The central part of the seminary burned and was replaced with another Italianate house, which is still there today.

Moving back toward Beverley Street you will come to the Hugh McDowell House at 19 Fayette Street. McDowell bought the

property in 1790 for fifty pounds. Based on hand-made nails and construction techniques discovered during a 1970s restoration, it is thought that the house was built shortly after McDowell died in 1793. The brick section of the home was built in the mid-nineteenth century and T.J. Collins added the distinctive arch in 1905. At the end of the street is the Smith-Thompson House at 701–703 West Beverley Street. Smith purchased the home on September 17, 1790, for fifteen pounds. He was a Scot who served in the Revolution and fought at the Battle of Guilford Court House. The house was begun possibly as early as 1791. The eastern half is a log structure covered with beaded wooden siding. The west end is a similar addition made about 1870.

Heading east and downhill on Beverley Street, you will come to what is now Grace Covenant Church. This was at one time the Baptist church. The first recorded Baptist missionary to the area was Daniel Witt, who came through Staunton in 1824, but there were not enough members in the area for a congregation until

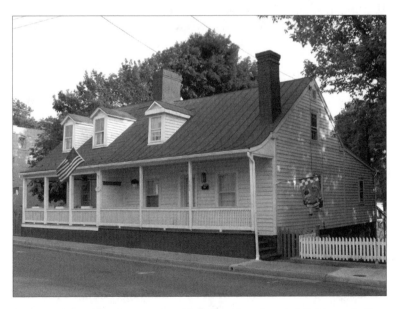

The left portion of the Smith-Thompson House on Beverley Street was built at the end of the eighteenth century.

1853. Construction of a church began in 1855 and it took two years to complete. Early photographs suggest that it was a simple rectangular brick structure with a gabled roof and a bell tower located centrally at the front. In 1901, the congregation agreed to move down a block to the corner of Church and West Beverley Streets. To raise money for the new structure, they had William Jennings Bryan speak at the Dunsmore Business College, which is today abandoned but still standing near the western entrance to Newtown at Beverley Street. Bryan would twice run unsuccessfully as a Democratic presidential candidate before becoming Woodrow Wilson's secretary of state. He is famous for serving Welch's Grape Juice at state dinners instead of wine.

The United Brethren bought the property in 1903 and sold their old church at the corner of Lewis and Johnson Streets to the German Baptist Brethren (now known as the Church of the Brethren). They then hired T.J. Collins to renovate the former Baptist church. To give it a gothic appearance, he used molded concrete designed to look like cut stone. In 1958, the United Brethren decided to build an education building. The only product that came close to Collins's material was PermaStone, but it did not match. Eventually, the whole structure was covered in the yellow material. In 1968, the Brethren merged with the Methodists and the church became St. Paul United Methodist. In the late 1990s, the congregation moved to outside the city and its buildings were sold to Grace Covenant Church.

Technically, Newtown ends at Beverley Street, but the historic district carries over north of Frederick Street. As the town moved both north and west, many of the same street names continued, but there are some additions. Fillmore is for Millard Fillmore, who visited Staunton during his presidency (1850–53). Institute refers to Virginia Female Institute, now known as Stuart Hall. Finally, Baldwin is not in honor of Mary Baldwin, but John Brown Baldwin, a prominent lawyer and judge who was part of a group that met with Lincoln and tried unsuccessfully to keep Virginia in the Union. In 1865, Baldwin served as Speaker of the House of Delegates.

Across the street from Trinity Church is Staunton's first permanent public school, built in 1887 and named after Stonewall

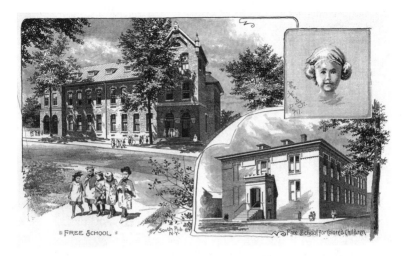

This is the way the Beverley Street School looked when Woodrow Wilson visited Staunton. This image comes from a booklet produced to encourage Northern investment in Staunton. This may explain why the African American school was included in the drawing. *Courtesy of the Hamrick Archives.*

Jackson. When Woodrow Wilson visited Staunton for his birthday in 1912, it was here where he reviewed the parade held in his honor. As the Staunton Military Academy Mess Hall, the next year, T.J. Collins and Son remodeled the facility, wiping away any trace of the building Wilson had used. The present façade is inspired by the Arts and Crafts style. It served as a school, first public and then private, until the 1990s.

Just down the street from the school is the educational building for Central United Methodist Church, designed by Richmond architect John Stafford Efford in 1964. The parking lot between these two buildings was the first home of the Wesleyan Female Institute. The church tore it down in 1976, but bricks and molding from the façade were saved and can be found on the front of John D. Eiland Distributing Company in Verona. Central United Methodist origins go back to Sampson Eagon, who opened a blacksmith's shop in 1793 on what is now called Gospel Hill. The site gained its name because of Eagon's regular prayer meetings. In 1800, the congregation purchased the property where the present

church now stands from Mayor Jacob Swoope for fifty pounds and constructed a one-story brick building. A new church was built in 1834 and then replaced by an even larger Gothic structure in 1859. The Baltimore Congress met in Staunton in 1861 and most members decided to affiliate with the Southern branch of the church. As a result, in 1870 the African American members left to form their own church.

In 1892, a March snowstorm caused the roof of the church to collapse, damaging the pulpit, organ and many of the pews. Philadelphia architect Sidney Winfield Folk designed a new Romanesque Revival structure, which was dedicated in 1896. In 1905, TJ Collins extended the building eastward and designed the stained-glass windows that front Lewis Street. The Willson parking lot just above the church on the corner of Lewis and Frederick Streets was the site of a late Victorian house until the 1970s.

On the other side of Lewis Street is Faith Lutheran Church. The Lutherans first met where the Clock Tower Building is now located on the corner of Central Avenue and West Beverley Street. In 1888, Central Lutheran Church was moved to 17 North Lewis Street. The rear of this structure is still visible. The church added a Colonial Revival façade in the twentieth century. In 1959, Central Lutheran's congregation moved out toward Staunton's developing suburbs on North Augusta Street to form Christ Evangelical Lutheran Church.

Across the street from the parking lot is Second Presbyterian Church. It was formed in 1875 with the help of a number of prominent citizens, including Jedediah Hotchkiss. When Miss Mary Julia Baldwin died in 1898, she left the congregation a house for a manse (minister's home). By 1900, the church was too small and William Frank Dull designed a Gothic Revival structure, which was built in 1902. The building is painted white in part because it was severely damaged by fire right before Christmas in 1946. In 1958, the Lexington Presbytery encouraged Second Presbyterian to close in favor of a new church, Covenant Presbyterian, being built at the end of Coalter Street in Staunton's developing suburbs. Instead, the church responded by building a new educational wing.

Farther up on your right is Stuart Hall. Like other schools in the city of Staunton, Stuart Hall was not the institution's original

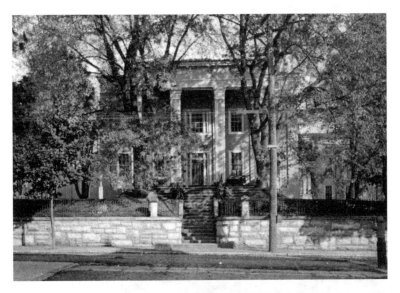

Virginia Female Institute (Stuart Hall) was founded in 1843 and Old Main was built in 1846. It was designed by Edwin Taylor. *Courtesy of Historic Staunton Foundation.*

name. Soon after the founding of Augusta Female Seminary (now Mary Baldwin College) in 1842, the members of Trinity Church became interested in developing a school for the women of the city of Staunton based on the principles of the Episcopal Church. They founded the Virginia Female Institute in September of 1844. Rather than start from scratch, they chose to redevelop an existing institution, the Kalorama School, which had been in operation since 1831 under the guidance of Mrs. Maria Sheffey. The Greek Revival "Old Main" was designed by Edwin M. Taylor and built in 1846. The school closed briefly during the Civil War to allow the facility to be used by the Virginia School for the Deaf and Blind.

In 1880, the Reverend Richard H. Phillips resigned as principal and the school's board hired Mrs. J.E.B. Stuart, the widow of the Confederate general. Mrs. Stuart brought name recognition to the school, but she also brought discipline. She implemented dress code rules that dictated even material and color selection of the students' attire. Mrs. Stuart also limited the number and content of letters her students could send to parents or boyfriends. In 1899, she

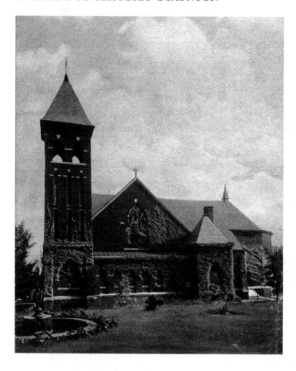

Emmanuel Episcopal Church as originally designed by T.J. Collins. *Postcard from the collection of the author.*

resigned and was replaced by Miss Maria Pendleton Duvall, who introduced female athletics. In 1907, the Virginia Female Institute became Stuart Hall in honor of Mrs. Stuart's contribution to the institution.

The Christian Baker House is one of a number of Victorian structures that are now part of the Stuart Hall Campus. It was built in 1886 in the Queen Anne/Eastlake style. Baker was a Lutheran who moved to Staunton in 1866 to open a grocery store. He bought food directly from the farmers rather than by commission, which encouraged the city to become a large wholesale market.

Across the street from Stuart Hall is Emmanuel Episcopal Church. It was formed when then Trinity rector, Walter Hullihen, tried to influence the vestry elections. Instead, he only succeeded in making half of his congregation angry. The vestry members involved called for his resignation, but he refused. When he then insulted them from the pulpit, eighty members petitioned for a new

parish in March of 1893. Their first priest was Reverend Robert Carter Jett. T.J. Collins designed the structure, which was built in 1894. Mrs. J.E.B. Stuart was an early member and made the structure the virtual chapel for Virginia Female Institute. The tie between the two institutions still exists today. In 1902, Emmanuel hired New York architect A.H. Ellwood to expand the facility. He also reoriented the church. Jett went on to found Virginia Episcopal School in Lynchburg and become the first Bishop of Southwestern Virginia. His replacement, William McDowell, later became Bishop of Alabama. T.J. Collins and Son designed the Parish Hall in 1929. The church has a very vivid interior that reflects an Anglo-Catholic tradition, which was popular around the turn of the twentieth century.

Finally, there is the present Baptist church just past Emmanuel. The Baptists were next to Trinity Church for less than twenty years before they decided to expand again. In the mid-1920s, they began buying land on Frederick Street. The church hired Charles M. Robinson, a University of Virginia graduate who designed many of the early buildings of what is now James Madison University. Construction began in 1929 and the first services were held in 1930. Unfortunately, the building was not complete. The congregation could not even afford an organ. In 1937, the Strand Theatre donated its organ, but the church was still short of cash. It still owed $8,550 on the 1903 structure the congregation no longer used. Finally, in 1938 they sold it at a loss for $6,000. The church debt was not retired for another nine years, but today the church is strong and vibrant.

This is just a small sampling of what Newtown has to offer architecturally. The community began to suffer as many absentee landlords took over properties, but since the area became a historic district in 1983 it has made a tremendous comeback.

The Graves of Staunton

When William Beverley created Staunton, he set aside land for both the courthouse and the parish church. With the creation of the churchyard, there was an understanding that it would also serve as a burial ground for the village. Most of the community's residents were not members of the Church of England, and there were other denominational cemeteries, but many of Staunton's citizens were buried at what is now the Trinity Churchyard.

Walking around the churchyard today, it appears very neat and orderly. If you think to yourself, "There is no way this amount of land could hold that many people," you are correct. The last public burial was in 1848. The present site reflects almost a century and a half of reorganization and removal.

Shortly after the graveyard filled, the tombs of Staunton's dead began to compete with the church itself. By the mid-1850s, the parish needed a larger facility. As the church prepared for the construction of what would be the last church on the site, the issue of graves arose. The vestry agreed that no one could remove their relatives without a church official present. The area of the new building was marked and a campaign began to contact living relatives. By the time of construction, all but twenty-three of the bodies had been removed. The remainder were sealed within the new structure's foundations and their names were listed with the church. Trinity

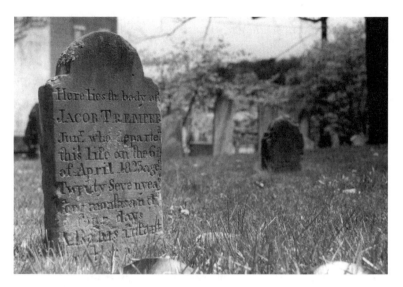

The Trinity Church Graveyard. *Courtesy of Historic Staunton Foundation.*

removed these bodies and reburied them in the churchyard in 1957 during a major renovation of the sanctuary.

After this effort by Trinity, the city approached the church with a proposal. Staunton wanted to extend Lewis Street south of Beverley. This required them to take part of the eastern edge of the churchyard. The vestry agreed to give the town the land on condition that the local government build and maintain a fence around the whole property. Staunton's council agreed and installed a wooden board fence.

After the Civil War, both graves and fencing again became issues. In 1869, Trinity took its present form, when side aisles were added to the church. Bodies had to be removed from the graveyard, so the vestry followed the same procedure as before. By this time, the fencing was over twenty years old and falling apart. The vestry complained to council that the city had failed to maintain the fencing and cows and pigs were getting onto church property. Again in 1872, they approached the city about fixing the fence but nothing happened. That year the church also began work on a parsonage in the northwest corner of the yard. Once again, bodies had to be removed.

In 1895, the city council successfully convinced the Reverend Hullihem to let them regrade the western portion of the churchyard so that the dirt could be used on Central Avenue. The city promised to replace the graves, but relatives objected. In the end, the work was completed and a number of parishioners left to join the new Emmanuel Church. Finally in 1900, frustrated by the lack of activity on the city's part, the vestry acquired the present iron fencing from the old courthouse. The city intern paid for its installation.

By 1922, all issues involving the churchyard had been settled, except the matter of the eastern edge. That year, Trinity Church decided to expand its Parish Hall. The city took the opportunity to approach the vestry over widening Lewis Street. They agreed to split the cost and Sam Collins designed the present brick wall. Collins also designed the new Parish Hall. Construction began in the late summer. Early on, workmen uncovered the remains of thirty previously unknown, unmarked graves. The bodies were given new coffins and then reburied together in another area of the churchyard.

With Trinity Churchyard full, the local government looked outside the town limits for a new site for a cemetery. In 1849, they purchased twelve acres just outside of Newtown on Beverley Street. The first burial in Thornrose Cemetery took place on March 29, 1853, and it was formally dedicated two months later. For the next twenty five-years, the site was simply an open field with a few trees. The first major event on the property took place on September 25, 1888. During the Civil War, 1,777 Confederate soldiers had been buried at Thornrose. With Reconstruction over, Staunton, like many other Southern cities, decided the time had come to honor its dead with a memorial. The monument was placed at the highest point in the cemetery and dedicated by Generals Thomas Rosser, Jubal Early and then-Governor Fitzhugh Lee.

This might have been the last major monument in Thornrose Cemetery if it had not been for Arista Hoge. Born in Scottsville, Virginia, in 1847, Hoge came to Staunton in 1872. He worked first in a dry goods store and then sold insurance with W.H. McChesney. Finally in 1885, he became city treasurer. Staunton was facing a debt crisis. Hoge reissued the city's bonds at 4.5 percent and cut

The Thornrose Cemetery Gatehouse, designed by T.J. Collins.

the debt almost in half. He then went on to become president of the Thornrose Cemetery Company in the late 1890s. He began by personally overseeing the landscaping. Next, he commissioned T.J. Collins to design a perimeter wall and the gatehouse, all of which were completed by 1905.

There are many interesting characters buried at Thornrose. Cemetery President Hoge's monument is just inside the gates to the right. T.J. Collins, who designed many of the structures at the facility, is also buried here. There is John Echols, a Confederate general who distinguished himself after the war by saving Staunton's failed banking system; local historian Joseph Waddell; Mary Julia Baldwin and her assistant Agnes McClung; and Stonewall Jackson's cartographer, Jedediah Hotchkiss.

There are also some colorful individuals buried at Thornrose. Eva Clark was a circus trapeze artist who may have been caught in a love triangle. She was shot and lay wounded at King's Daughters Hospital for several weeks before dying. The circus band came for many years and played by her grave. There is also a Charlottesville

Fairview Cemetery.

madam and a Confederate female spy. Finally, there is a woman who was widowed twice and is buried between her two husbands. Before her death in 1988, she would go to Thornrose Cemetery each day and read the paper to her husbands.

After the Civil War, Thornrose opened an African American section, with the first person being laid to rest there in 1870. Many African Americans, however, were buried outside the city. Fairview Cemetery was established jointly by Mount Zion Baptist Church and Augusta Street United Methodist Church in 1869. To get there, take North Augusta Street until you get to the post office and then make a left onto Lambert Street.

The cemetery is on a six-acre plot of land given by the plantation owner Simpson Taylor, with additions made in the 1920s and then again after World War II. According to Jedediah Hotchkiss's map of Augusta County, the African American community of Sandy Hollow once surrounded the cemetery. Sandy Hollow was one of a number of black enclaves within Augusta County during the late nineteenth century. Together with the Friends of Fairview

The Temple House of Israel Cemetery.

Committee, students from Mary Baldwin College are researching the over two thousand individuals who were buried here. The property is picturesque, with mature trees and shrubs. The groundskeeper's house may have originally been the southernmost tollhouse on the Valley Turnpike and if so was moved to the site in 1871.

A little farther down North Augusta Street is the cemetery for the Temple House of Israel. Having land for its own cemetery was important to the congregation, so this property was purchased shortly after the temple was organized. Many of the families buried here were merchants who came to Staunton during the boom years around the end of the nineteenth century. Temple House of Israel has been a member of Union for American Hebrew Congregations since its inception in 1876. It operates within the tradition of Reform Judaism.

Few people traveling on Route 250 between downtown Staunton and the interstate notice the cemetery at the Powell Street light. It is a National Cemetery, but most locals used to call it the "Yankee Cemetery," with all the negative connotations that come with the

term Yankee in the South. According to historian Dr. Catherine Zipf, after the Civil War, the Federal government sought to make its presence known in the conquered South by developing the National Cemetery System.

In 1861, the War Department issued General Order 75 to cover the burial of Union dead. Soldiers could be interred in local graveyards, but given the choice, officers were to select a space to be exclusively a Union burial ground. Congress also provided funds for land to be purchased. By the end of the war only 101,736 of the total 359,520 Union dead had been buried in a National Cemetery. To make matters worse, few of the graves in the South were treated with respect. The quartermaster of the army's office was given the job of bringing order to the system. Within a year, fifteen pieces of land had been secured for such a purpose in Virginia alone and the process of transferring bodies began. In the end there were over forty-five sites within the former Confederacy that needed to be organized.

Rather than allow the process to be haphazard, Quartermaster General Montgomery C. Meigs developed an overall plan. To

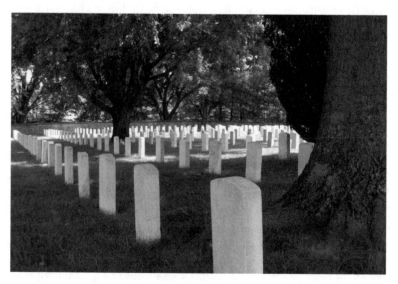

Staunton's National Cemetery.

protect the dead and make sure the grounds were kept up, each facility would have a former Union soldier to act as a caretaker and enforce the Union presence on Southern soil. Some facilities already existed, so Meigs developed a series of set pieces that would allow all the cemeteries to appear uniform. All would have a wall with a gate; to the right of the gate would be a lodge for the superintendent. There would also be a rostrum for speakers, and in the center of the cemetery a flagpole. Additionally, all gravestones were to be uniform in size and material.

While Meigs allowed the lodges to be made of local materials, they had to be uniform in design. All National Cemetery lodges are L-shaped in plan and built in the Second Empire style. Even before the Civil War, the Federal government had pushed this form of design. Washington liked the fact that the French government-run art school, the École des Beaux-Arts, had adopted classical forms with a mansard roof as their national style. Meigs was developing the façade of his lodges at the same time the Department of War was finalizing plans for the new State, War and Navy Building (now the Old Executive Office Building). Once Meigs knew that Alfred Mullett had chosen the Second Empire style for the War Department's headquarters, he did the same for the lodges. In effect, each lodge was a miniature symbol of the Federal government's ability to wage war on the South should it ever get out of line again. Today, while part of the slate roof on Staunton's lodge has been replaced with siding, the facility remains intact to remind Southerners who won the war.

The Railroad
and the Wharf

Throughout Staunton's history, transportation has been critical to the community's growth and prosperity. In the first half of the nineteenth century, toll roads or turnpikes made the town a center for commerce. Yet despite the arrival of the Staunton and James River Turnpike in 1824, most traffic through Staunton either traveled north–south or to the west. The Blue Ridge Mountains, which had frustrated John Lederer in 1669, still led people to associate themselves with the valley instead of the state as a whole. This all changed with the arrival of the Virginia Central Railroad from Richmond to Staunton in 1854. The railway transformed the economy of the community. Goods no longer had to pass down the Valley Pike. Merchants could reduce their prices by one-third and still keep their profit margin. In return, the railroad allowed valley farmers to sell their goods to people living in eastern Virginia. Additionally, the town's link to the state capital would become crucial with the coming of the Civil War.

The Virginia Central began life as the Louisa Railroad in 1836, only changing its name when it arrived in Charlottesville in 1850. Construction continued until the line reached the mountains, at which time the Virginia Central turned to the largely state-owned Blue Ridge Railroad for help. The latter hired Claudius Crozet, for which the town west of Charlottesville is named, to build a series of tunnels running under the Rockfish Gap near Afton Mountain.

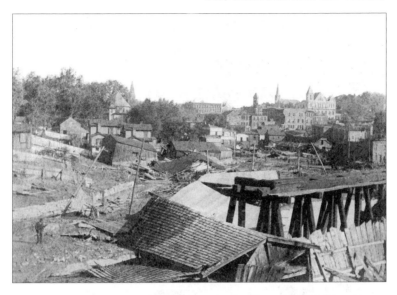

Damage left by the 1896 flood. The picture is taken from the C&O Flats. *Courtesy of Historic Staunton Foundation.*

When completed, Crozet's Blue Ridge Tunnel, at 4,263 feet, was one of the longest in the world. At the same time, the Virginia Central laid track from Waynesboro to Staunton. The first brick station was completed in 1860. The next year, a depot was added to the west. Meanwhile, Staunton's industry and commerce began to focus around the area that today we call the Wharf.

To begin the tour of Staunton's railway past, let us start at the bottom of Church Street where it meets Middlebrook Avenue. Today this is a quiet park, but even fifty years ago it would have been a busy industrial area. The arches here date back to the Virginia Central and continue to carry both passengers and freight west into the Appalachian Mountains. During the flood of 1896, these arches trapped debris that had come both from downtown Staunton and from the lake at the racetrack on Middlebrook Avenue.

Past the stone arches and to the right is what used to be known as the "C&O Flats." Originally, this housed a small engine shop, a roundhouse and yard. The first engine house burned in July of 1872 and the Chesapeake and Ohio replaced it with a

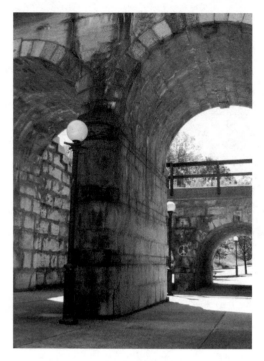

The arches under the Chesapeake and Ohio tracks near Middlebrook Avenue.

modern brick roundhouse that could hold thirteen locomotives. In 1889, the railway moved its division point from Staunton to Charlottesville and built a new mechanical shop at Clifton Forge. It sold the roundhouse to O.K. Lapham Company, which made tannic acid, but the yard remained in use. Today, the area is used by the Buckingham Branch Railroad, which was founded in 1989 and operates over two hundred miles of track throughout Virginia.

Heading east on Middlebrook Avenue, you will pass the Klotz Building on the corner of South Lewis Street. Sunspots Studios creates unique pieces of glass art here. They have glass blowing demonstrations that run until 4:00 p.m. most days. As you continue on Middlebrook up the hill, you will see the Wharf on your left and a set of stairs on your right that leads to the station complex. Take the stairs. At the top are three Chessie System Western Maryland branch cabooses. In 1963, Chesapeake and Ohio purchased the Baltimore and Ohio. The Western Maryland had been owned by the latter since

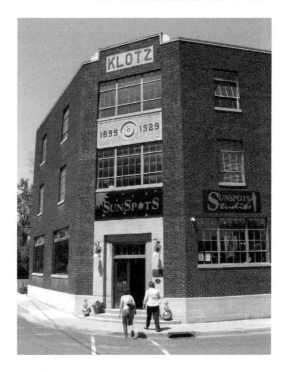

Sunspots glass studio.

1927. It operated independently until 1973, when it was consolidated into the Chessie System. Most American railways have abandoned the use of the caboose and Staunton was lucky to secure these. They are not, however, the only railway cars in your immediate area. If you walk around to the right rear of the Depot Restaurant, you will see that they have utilized a number of boxcars for their facility.

One of the biggest promoters of the Virginia Central in Staunton was the town's mayor, Nicholas K. Trout. Born in Greenville, just south of town, in 1817, he became an assistant to Jefferson Kinney, the county clerk of courts, when he was only fifteen. Trout was very gifted in the law and he passed the bar exam by the age of twenty-one. In 1852, he became mayor and held that position throughout the Civil War. In 1860, Staunton was a town of about four thousand and, like many communities in the western part of the Commonwealth, it wanted to remain in the United States. Shortly after Lincoln was elected, a rally was held at the courthouse

The Wharf as it looks today.

for the Friends of the Union. Lincoln's family had, after all, lived in Augusta County before moving west. When the president called for volunteers, Staunton instead produced the Fifth Virginia Regiment, which went willingly with Virginia into the Confederacy.

From the beginning, the railroad played an important role in the War Between the States. In June 1861, Thomas J. (soon to be known as Stonewall) Jackson was sent to Martinsburg, (West) Virginia, to destroy the Baltimore and Ohio workshops. He found over forty locomotives. Rather than destroy them all, Jackson had Henry Locust and Captain Thomas Sharp organize the transport of the fourteen best from Martinsburg to Strasburg, Virginia. It took four days using mules and a portable track. The last locomotive was a camelback. By the time it arrived in Strasburg, that city was at risk of being seized by Union forces, so Jackson had it hauled down the Valley Turnpike to Staunton and then put on the Virginia Central line to be transported to Richmond.

The Virginia Central has often been called the "lifeline of the Confederacy." During the war, Staunton served as a distribution

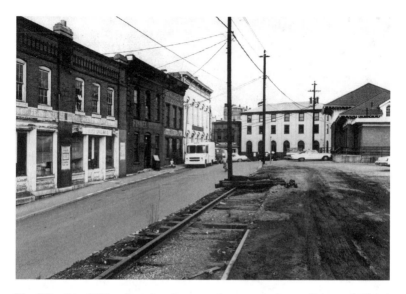

The Wharf in 1971, when the city wanted to tear it down. *Courtesy of Historic Staunton Foundation.*

point for both food from the Shenandoah Valley and Southern troops going into combat. The area where the Wharf is now was made up of small factories and armories that supplied Jackson's troops. In May of 1864, Union forces under Major General Franz Sigel were defeated at New Market, but the next month General David Hunter successfully made it down the valley. On June 6, 1864, he occupied Staunton without firing a shot. Mayor Trout worked hard to protect the city. He talked Hunter into sparing the educational institutions, but his troops burned the depot, railway station and the office of the *Staunton Spectator*. They destroyed the factories and looted shops before leaving on June 10 to attack Lexington.

Hunter, however, was in such a hurry that he did not stay to make sure that the city had been effectively crippled. His troops missed the printing presses of the other local paper, the *Vindicator*, and they did not do a very good job of destroying the depot. Part of the restaurant and shops you see before you is the original structure built by the Virginia Central before the war. The rest, minus the glassed-in patio,

The Depot originally built by the Virginia Central Railway.

was rebuilt in 1867. The Belgian pavers are also original. The Union army passed through two more times before the end of the war, but they left much of what remained of the town untouched.

Walk toward the station and take the iron bridge, which was built in 1905, over the tracks. On the other side is a nice little shaded park that gives you a wonderful view of the city. This neighborhood is where the movie *Hearts of Atlantis*, starring Anthony Hopkins, was filmed. Behind you is Sears Hill. It is not named for the department store, but rather the educator Dr. Barnas Sears.

Before the Civil War, there were no statewide public school systems in the South. Most middle-class and wealthy Southerners relied on private academies to educate their children. Northerners who came in contact with Confederate troops were shocked to discover that many could not read or write. After the war, there was a push to bring schools to the conquered states. In 1867, Massachusetts philanthropist George Peabody established a fund to support public schools in the South. He hired Sears, who was then president of Brown University, to administer the $3,484,000. Sears quit his job and began looking for a location that could provide

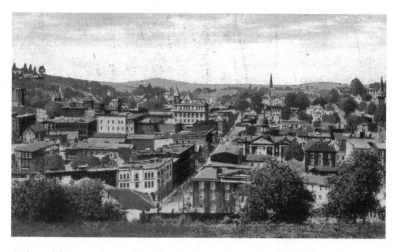

A view of Staunton from above the railway station, taken about 1910. *Postcard from the collection of the author.*

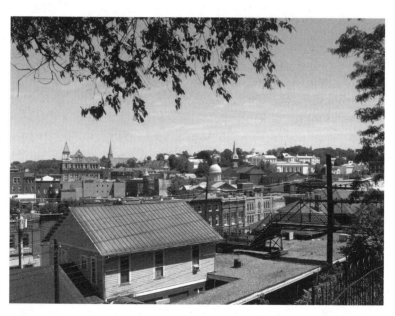

Looking north over the city today from Woodrow Park.

him with the transportation he needed and would be within a community that valued education. He chose Staunton and moved to the cottage you see at the top of the hill. Sears was instrumental in crafting the free education portion of the Virginia Constitution of 1870. He became superintendent of schools for Augusta County and Staunton. Even after Reconstruction ended, Sears continued to work here until he died in 1880. The Sears House is an excellent example of the type of architecture Andrew Jackson Downing sought to popularize right before the Civil War. It is a board-and-batten cottage with polygonal wing that held Sears's library.

After Union troops left in 1866, Mayor Trout began the process to trying to rebuild Staunton. Elected to the Virginia Senate, he continued to push for development within his town. According to a September 19, 1866 article from the *Rockingham Register*, "Staunton is full of life and enterprise. A tobacco factory and two large foundries have been built since the war. The streets were being re-laid and the gas lights are working." Part of this turnaround was due to General John Echols opening a local bank. Another key component was the Wharf. The area gets its name and many of its buildings from this period of the nineteenth century. Many of these structures you see were warehouses for commercial goods and wholesalers. There was so much traffic when the train came in that locals felt like they were at a port, thus the name.

In 1869, the Virginia Central merged into the Chesapeake and Ohio Railroad. As the line expanded into West Virginia, Staunton became an important business and industrial center that fed off the railroad. A number of West Virginia coal companies—including the New River Coal & Coke, the Fire Creek and the Thurmond Coal Company—had their main offices in Staunton. Goods headed for the coalfields were often stored at the Wharf. The Erskine Building at 5 Middlebrook Avenue is a good example. The Miller family built the building in the 1880s. They not only were wholesale grocers but also had interests in the coal industry. Even the depression of 1873 did not stop the area's growth, as witnessed by the Burns building, finished in 1874.

With the growth of commerce also came saloons and houses of prostitution. This gave the Wharf a rough image within the

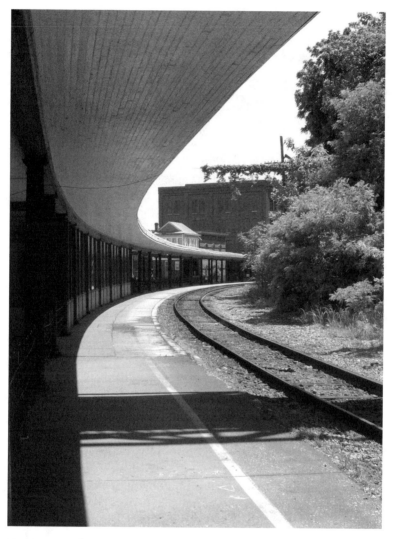

The station platform has not changed since 1906.

In the late 1960s and early 1970s, there was a push to tear down all these structures and build a highway. Luckily that did not happen. Instead, the Wharf is a collection of eclectic shops and houses the farmers' market on weekends.

community. There were also positive sides to the area. During the Depression, surplus food was distributed from warehouses on South Augusta Street. Yet for most, the Wharf appeared to be something temporary. In 1911, a gas cook stove started a fire that destroyed two buildings and gutted three more. In 1940, a gas tank in a vehicle exploded, leading to a fire that took all night to extinguish. When the railway became less important after World War II, unused structures were torn down to make way for parking. By 1971, the Wharf was seen as an eyesore that needed to be removed. Luckily, it was saved, made a historic district and is now a vibrant shopping area for Staunton, which other communities are trying to copy.

Two of the many commercial structures that are worth noting are 120–124 South Augusta Street and 119–123, which is across the street. The first structure has a pressed metal façade. The Victorians loved to make things out of metal. They made cast-iron trees, metal sheeting to look like masonry and iron columns painted

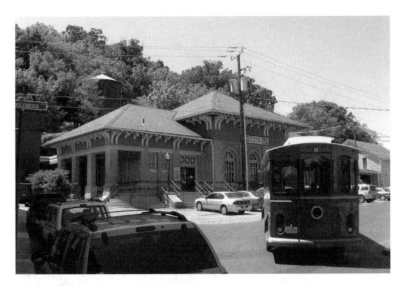

The Chesapeake and Ohio station, designed by T.J. Collins.

to look like marble. Little of this type of work exists in Staunton, making this building rare. The structure at 119–123 served as a wholesale grocery for Hoge and Hutchinson, who constructed the building around 1880. Despite the nature of their business, they put an exceeding amount of decoration into their structure.

The station itself was designed by T.J. Collins in 1905 and replaced a structure built by the Chesapeake and Ohio thirty-four years earlier. The new station opened in April of 1906 at a cost of almost $54,841.93. It remained active until the Chesapeake and Ohio ended passenger service in 1971. Amtrak still has a service that leaves from this station. The ride west to Chicago is one of the most scenic in the country. The water tank by the station dates to around 1903 and is one of the last surviving company tanks. If you had arrived here in 1906, you would have been met by the local streetcar. Staunton Power and Light Company began offering service in 1890, pulled by mules and running from the station to the Virginia School for the Deaf and Blind and back. By 1896, the service was electrified.

Next to the railway station is the American Hotel. Built in 1854, it offered the finest luxuries for travelers, including bathtubs. In the

The American Hotel at its worst. *Courtesy of Historic Staunton Foundation.*

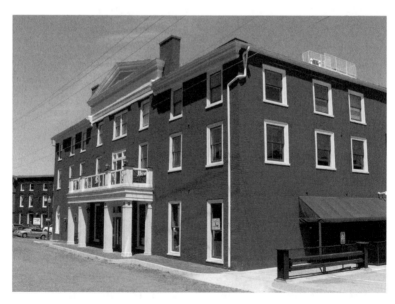

The American Hotel today, restored, and a mixed-use development.

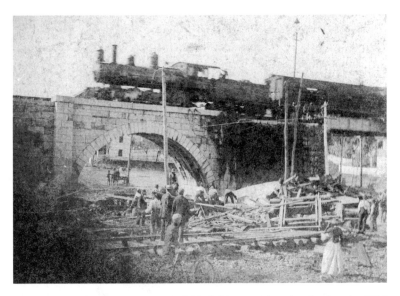

This image of the Chesapeake and Ohio bridge was shot shortly after the 1896 flood. Looking from the same spot today, the bridge has not changed. *Courtesy of Historic Staunton Foundation.*

1880s, part of the building became a shoe factory and then later a warehouse. The east wall collapsed in the early 1970s and there were calls for its removal. Luckily, this did not happen, the wall was rebuilt by the owner, and the whole structure was recently restored. Just past the American Hotel is the Witz factory building, which dates from about 1870. Isaac Witz manufactured work clothing here. His son Julius opened a furniture factory at the end of the nineteenth century and later purchased another facility in Basic, now part of Waynesboro. By the mid-twentieth century, Basic-Witz was a nationally known furniture manufacturer. This building was one of the first structures in the Wharf area to be adaptively reused in the 1970s. Finally, there is the White Star flour mill, which opened in 1892. For years, it produced some of the best flour in the region. In 1966, the company was put out of business by national chains. It is now one of the featured restaurants in Staunton.

If you head east on Greenville Avenue, you will come to the junction of Greenville and Commerce Avenues with Coalter Street.

Today it is the home of Staunton's watering can. Before World War II, it was a mess of roads and railway tracks. While the Chesapeake and Ohio, through the Virginia Central, was the first railroad in Staunton, it was by no means the only one. Laying tracks east–west went against the traditional north—south travel routes of the valley. In 1861, Jackson could have really used a railroad that went to Winchester. With this in mind, the Valley Railroad was formed.

In 1869, with Robert E. Lee at its head, the company went to Baltimore to meet with city leaders and the Baltimore and Ohio Railroad. They proposed to build track from Lexington to Baltimore to allow the Baltimore and Ohio access not only to the Shenandoah Valley but also to Central Virginia through Lexington. The Maryland-based railway was thrilled. It had been trying to make it into the valley since the 1850s. Both the Baltimore and Ohio and the city contributed $1 million each to the project. When funding fell short in the valley in 1871, the railroad bought up the rest of the stock, making it the controlling interest in the new company.

The track followed the path of the Valley Turnpike and the station in Staunton was placed just past the Chesapeake and Ohio underpass on what is now Greenville Avenue so that travelers could easily move from one company to the next. The line cut through the embankment to the right of the present stone arch. The first train from Harrisonburg arrived on March 3, 1874. Construction of the line continued until the economic Panic of 1873 halted construction south of Greenville, and the railroad did not reach Lexington until 1883. That same year the Staunton Depot was built across from the entrance to Western State Hospital, based on a plan by Baltimore and Ohio architect E. Francis Baldwin.

Unfortunately for the Valley Railroad, its competition was about to make it all but obsolete. In 1881, the Shenandoah Valley Railroad had reached Waynesboro and a year before Staunton had a station the company arrived in what would soon be called Roanoke. The new Norfolk and Western seriously damaged the profitability of the B&O line. To make matters worse, during the Panic of 1896 the Baltimore and Ohio lost control of the section of the line between Harrisonburg and Strasburg to the Southern

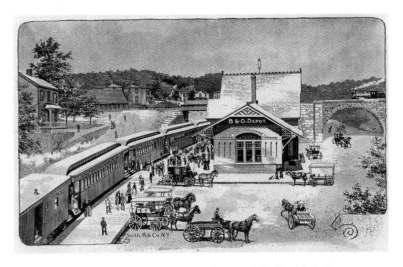

The Baltimore and Ohio Station in 1890. *Courtesy of the Hamrick Archives.*

Railroad. Without direct access to and investment from the parent company, the fleet of passenger cars and engines for the Valley Railway began to age. In the early 1930s, the Baltimore and Ohio introduced a diesel railcar, "The Tinker," to save money on the dwindling passenger service.

By 1939, the Baltimore and Ohio began negotiations with the Chesapeake and Western to buy the line. By 1942, the company was so desperate to unload the unprofitable Lexington end that it sold everything for $150,000. It had cost $3 million to build. The Chesapeake and Western in turn resold the Lexington assets to the Chesapeake and Ohio and the materials from the abandoned line for scrap for a total of $200,000. The Staunton passenger station became a gas station and in 1947 much of the freight yard was removed to create Commerce Avenue. The twenty-five miles of line from Staunton to Harrisonburg still exist, however, and are regularly used for freight. Next to Commerce, you will see a large circle of stones. These are the base of what was the Valley Railway turntable. It was saved and moved here around the turn of the twenty-first century.

Gospel Hill to Stuart's Addition

Staunton has long been a city of educational institutions. As we have already seen, it was a key junction not only for the railway, but also for the major roads that came before. Despite the benefit of transportation, Staunton never became an industrial center like Roanoke. Instead, the rural landscape of Augusta County encouraged those looking for the right environment to better the soul and the mind.

Virginia has a long tradition of trying to provide for the mental health of its residents. In 1773, the first publicly funded mental hospital in the New World was established in the colonial capital of Williamsburg. While the treatment received at this facility would appear by today's standards to be horrible, it was still better than to be put in prison, left on the streets or kicked out of the community to die. In 1825, the Virginia General Assembly agreed that a new hospital was needed to meet the needs of the western areas of the state and Staunton was selected as the location. When the Western Lunatic Asylum opened in 1828, it was one of only five such institutions in the country and the first structure west of the Blue Ridge Mountains built with state funds.

In 1836, Dr. Francis Taliaferro Stribling took over the facility and began reforms to turn the inmates into patients. Shortly thereafter, the state hired Thomas R. Blackburn to design an addition to the asylum. Blackburn was a Virginia architect who studied under

Western Lunatic Asylum (Western State Hospital) opened in 1828. It was designed by William Small and later modified in 1847 by Thomas Blackburn, who studied with Jefferson.

Thomas Jefferson at the University of Virginia. Today, he would be almost unknown if it were not for three volumes of his papers that are located at the Virginia Historical Society in Richmond. He was trained as a carpenter. Having worked on the construction of the university, he looked to nearby Staunton for possible commissions. Jefferson's influence can be clearly seen in the use of red brick with white columns and Chinese Chippendale railings. Blackburn's addition to the hospital was designed to meet the needs of more wealthy clients. He also created a summerhouse, gardens and transformed the front of the original hospital by adding the distinctive gabled pediment and columns. Blackburn even taught some of the patients carpentry, under the direction of the superintendent.

Western State Hospital continued to grow throughout the rest of the nineteenth and into the twentieth centuries. For some living in

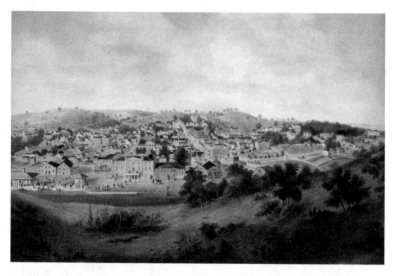

An image of Staunton created by German artist Edward Beyer in 1857. *Courtesy of Historic Staunton Foundation.*

the western half of the state, it was common to say "you are driving me to Staunton" in place of "you are driving me crazy." By the early 1970s, the facility was considered too old. Western State moved near the junction of Interstate 81 and Route 250 and the buildings were turned into a prison. Early in the twenty-first century, the prison closed. Rather than tear down the buildings, the complex is presently being redeveloped into a residential community.

Moving up from the business area, around the railway you pass through a block of Queen Anne, Shingle-style and Colonial Revival homes. At the corner of Beverley and Coalter Streets stand three impressive structures. The home at 238 East Beverley Street dates from the 1840s and is supposed to have been built on the site of Sampson Eagon's blacksmith shop. T.J. Collins and Son made the Colonial Revival additions to this structure in 1915. Across the street is the Effinger House. As odd as it may seem, it was originally built as an Italianate structure with an ornamental tower in 1856. In 1898, T.J. Collins remodeled it into a Chateauesque home. Twenty years later, the building gained its present Colonial Revival appearance. Today it serves as part of the Woodrow Wilson Presidential Library

complex. The third major structure at 333 East Beverley is a large turn-of-the-century home with Arts and Crafts influences.

The Gospel Hill area of Staunton has a wide variety of homes that range in construction date from 1810 to the 1940s. The whole area remained largely undeveloped until the arrival of the Virginia School for the Deaf and Blind in 1839. Most of the structures built during the 1840s were brick and simple in design. After the Civil War, however, there was an explosion of Victorian styles. Seven houses in the Gospel Hill Historic District are listed on the National Register of Historic Places: Woodrow Wilson's Birthplace (24 North Coalter Street), the Oaks (437 East Beverley Street), the Thomas Michie House (324 East Beverley Street), the J.C.M. Merillat House (521 East Beverley Street), Oakdene (605 East Beverley Street), Catlett House (303 Berkley Place) and the Arista Hoge House (215 Kalorama Street).

Before construction began on the Virginia School for the Deaf and Blind in 1839, Beverley Street ended at what is now Coalter Street. Even after the road opened, few people were prepared to build here. Until the mid-nineteenth century, citizens had to rely on wells for their water, which discouraged people from living on the hills. Finally, in 1848 the town began pumping water from Buttermilk Springs, and Gospel Hill began to grow.

Moving down East Beverley Street, many of the Colonial Revival homes, such as 305 and 402, were built in the first decade of the twentieth century. The home at 324 Beverley is one of the older structures on the street. Built around 1848, it has been owned by the founder of the city's oldest bank, Stonewall Jackson's engineer and a Virginia Supreme Court justice.

The home at 437 East Beverley is better known as "The Oaks." Originally built around 1840, it was purchased by Jedediah Hotchkiss after the Civil War. Hotchkiss was born in New York and came to Virginia when he was nineteen to serve as a tutor for a family in Mossy Creek. He joined Stonewall Jackson's staff in March of 1862. Hotchkiss was a mapmaker, organized transport and served as a scout and combat engineer. He built and blew up roads and bridges. More importantly, he kept his maps and a war journal. He was at Fredericksburg, Chancellorsville, Gettysburg,

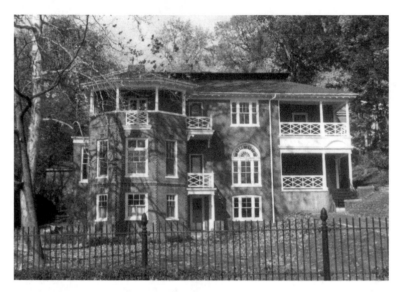

The Oaks, the home of Jedediah Hotchkiss, Stonewall Jackson's mapmaker. *Courtesy of Historic Staunton Foundation.*

the Wilderness and Jubal Early's raid on Washington. Hotchkiss ended the war in Lynchburg. Back in Staunton, he worked tirelessly to bring economic benefit to the South. He used his cartography skills to document possible mineral resources in Virginia and West Virginia. In 1888, Hotchkiss built onto the front of the house, creating the present façade. Later, Fletcher and Margaret Collins helped save the house in addition to developing live theater in Staunton.

Just past two Italianate homes on the right is the entrance to the Virginia School for the Deaf and Blind. When the House of Delegates voted sixty-five to forty-nine to place the Virginia Institution for the Deaf, Dumb and Blind in Staunton over Richmond, it was seen as an educational experiment. James Bell gave five acres of land on the east of town. The state paid Baltimore architect Robert Cary Long Jr. $250 to design the main structure. Some of Long's other work includes the Athenaeum, which today houses the Maryland Historical Society; the Library Company of Baltimore; and St. Timothy's Church in Catonsville, Maryland.

The School for the Deaf and Blind project was always short of funds and the building was not completed until 1846. Long's Greek Revival design balanced well with Blackburn's work on Western State. Once completed, the grounds of the institution became a park for the community.

The school building was divided into four wings that separated boys from girls and the deaf children from those who were blind. This division was due to the vast differences in educating the two exceptionalities. The Reverend Joseph Dennie Tyler came to Staunton from the Hartford School for the Deaf to become the first principal of that portion of the institution. The first principal to head the blind school was Dr. Jean Charles Martin Merilatt. He was originally from Bordeaux, France. Merilatt came to Staunton from the Pennsylvania Institute for the Blind. When the Reverend Tyler died in 1852, Dr. Merilatt took over the running of the whole facility.

The Virginia School for the Deaf and Blind was established with the idea of teaching the students a trade so that they could provide for themselves when they left. Unlike many academies of the time,

V. S. D. B. Staunton, Va.

Construction on the Virginia School for the Deaf and Blind began in 1839, but because of budget shortfalls it was not completed until 1846. *Courtesy of Historic Staunton Foundation.*

75

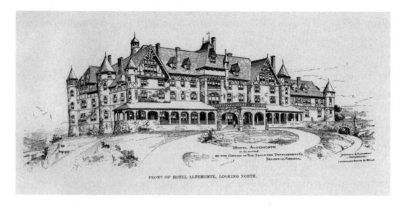

The Altemonte Hotel was to have been the centerpiece of the Staunton Development Corporation. Unfortunately, like many Virginia land development schemes of the 1890s, it was never realized. *Courtesy of Historic Staunton Foundation.*

students could attend for free if their parents could not afford to pay. During the turmoil of the Civil War, the facility was used as a hospital. Rather than close the school, the State of Virginia took control of the buildings of Virginia Female Institute, present-day Stuart Hall, and used them as a location from which to educate the deaf and blind.

Just past the Virginia School for the Deaf and Blind are two structures on the left that capture the variety of Victorian design. The structure at 521 East Beverley Street was built for the school's administrator, Dr. J.C.M. Merillat. The steep gabled roof, diamond-paned windows, bargeboards and board and batten siding reflect a style of architecture popularized by Andrew Jackson Downing in the decade before the Civil War. The home at 605 East Beverley is also a Gothic-inspired structure, but it represents the excess of the 1890s. Oakdene, as it was called, was built for Edward Echols by the architectural firm hired to design the Altemonte for the Staunton Development Corporation. Echols was a major backer of the project. While the hotel was never built, he went on to be lieutenant governor of Virginia from 1898 to 1902.

About a quarter-mile farther on the right is the only surviving exposed log structure in the city. In 1866, Edmond Cabell, "a free man of color," purchased a parcel of land from Alexander and

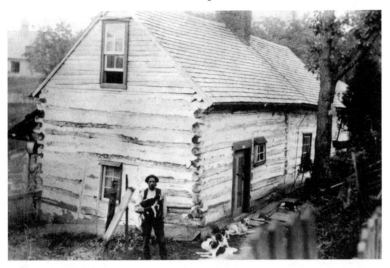

The Cabell home is the only exposed log structure left in the city. *Courtesy of Historic Staunton Foundation.*

Sarah Taylor for fifty dollars. Within four years, he had built the two-room structure you see today. There was a time when most buildings in Augusta County were similar to this one, but over time they were replaced. This one survived in large part because it has remained in the same family for 140 years.

Turning back up Beverley Street, make a right turn onto Berkley Place. At the top of the hill, head left. Many of the homes on this street were built during the 1880s and 1890s and are either Queen Anne nor Stick style. The most imposing structure is number 303. It was built by the Catlett family in 1896 and has a mixture of Shingle style with a Queen Anne turret.

At the base of Berkley Place on Coalter Street is Woodrow Wilson's Birthplace. In 1845, Staunton's First Presbyterian Church purchased this plot of land on what was then known as the Winchester Road. The minister's house (manse) was built by John Fifer during the next year for $4,000. From today's standards the house faces backward, but in 1846 what is now Coalter Street marked the end of town. The rear façade has an impressive Greek Revival colonnade that dramatically overlooks the city. Members of the Wilson family were

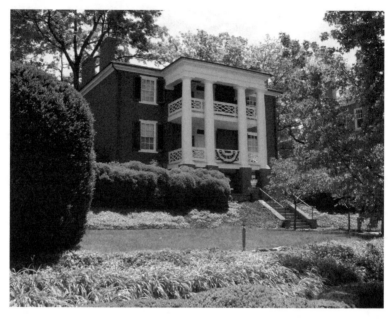

Woodrow Wilson's Birthplace was the home of the minister of First Presbyterian Church from 1846 until 1929.

the second group of residents in the manse. They stayed in Staunton for only eighteen months, but during that time, Thomas Woodrow Wilson was born. On December 28, 1912, the newly elected twentieth-eighth president returned to Staunton for his birthday. Since then his birthday has been celebrated within the community and his home is open for free tours on that day annually.

The president died in 1924 and two years later Mary Baldwin College began negotiations to purchase the manse to turn it into a museum. During the Depression, the college turned the effort over to a local group and in 1934 the Garden Club of Virginia created the present bowknot boxwood garden. Four years later, the property was taken over by the Woodrow Wilson Birthplace Foundation. Franklin D. Roosevelt officially opened the manse as a "Shrine to Freedom" in 1941. In 1990, the foundation transformed the Effinger House into a seven-gallery museum housing a research library and Wilson's 1919 Pierce-Arrow White House Limousine.

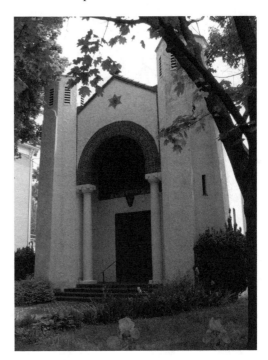

The Temple House of
Israel, designed by Sam
Collins in 1925.

The organization has been known as the Woodrow Wilson
Presidential Library since 2003. It is open from 9:00 a.m. to 5:00
p.m. Monday through Saturday and Sundays 12:00 to 5:00 p.m.

Below the manse, at the bottom of the hill on Market Street
is the Temple House of Israel. The temple was founded through
the efforts of Major Alexander Hart. Born in New Orleans, he
fought for the South during the Civil War. He almost lost his leg
at Antietam, fought at Chancellorsville, was wounded again at
Gettysburg and was captured at the Battle of Third Winchester.
After the war, he married a lady from Richmond and they moved
to Staunton in 1876. Hart not only helped found the temple, he also
conducted all the services and led the congregation as its president
for its first eighteen years. He was also an active Mason.

For the first nine years, the group worshipped at various places
in Staunton; in 1885, they purchased 200 Kalorama Street for
$600, and worshipped there until 1926. In 1925, the cornerstone

First Presbyterian Church, built in 1872. *Courtesy of Historic Staunton Foundation.*

was laid for the current building. Sam Collins's design was inspired by Spanish Jewish architecture. The firm of Charles Connick Associates, based in Boston, created the stained-glass windows. The firm was one of the most celebrated stained-glass artisans in the United States for re-creating the colors and textures found in medieval glass. One of its other commissions was the great rose window at the church of St. John the Divine in New York City.

Across the street from the temple is the First Presbyterian Church complex. While Trinity (Augusta Parish) was the first official church in Staunton, many of the community's early residents were actually Presbyterian. Finally in 1804, they gained permission from the Lexington Presbytery to form a congregation. They met at Trinity until 1818, when they built their own structure. It was a simple church that served the congregation well through the Civil War. During this time, the Augusta Female Seminary, now Mary Baldwin College, grew around the building. When First Presbyterian Church needed to expand, it moved across the street to its present location. The new Romanesque Revival building was dedicated in 1872.

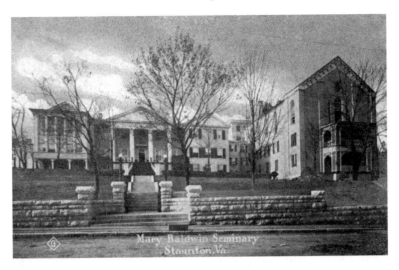

Mary Baldwin Seminary around the turn of the twentieth century. The building on the far right is the original Presbyterian church from 1818. From the 1870s onward, it served many functions for the college, including a dining hall and chapel. By 1962, it was considered structurally unsound and was demolished. *Postcard from the collection of the author.*

On the other side of Frederick Street is Mary Baldwin College. It was founded in 1842 by Rufus Bailey and received its charter from the state legislature two years later. About the same time, work was completed on Old Main, a Greek Revival structure designed by Edmund Taylor. One of Bailey's first students was Miss Mary Julia Baldwin. In 1855, local historian and newspaper publisher Joseph Waddell was elected to sit on the board of trustees. At the same time, the Reverend Joseph R. Wilson, father of Woodrow Wilson, became chaplain and principal of the school. During the Wilsons' short stay in Staunton, Jessie Wilson became a good friend of Miss Baldwin. Later, Mrs. Wilson saw to it that her two daughters and a number of her female relatives became Miss Baldwin's pupils.

In 1863, Waddell was faced with the task of trying to find a new principal in the middle of the Civil War. During the conflict, upward of 80 percent of Southern men were involved in the war effort. This provided an opening for many women to take on duties not normally open to them. Waddell turned to Miss Baldwin

because she had a "peculiar talent in teaching and managing girls" as a Sunday school teacher. It was one of the wisest decisions he ever made. While other schools and academies in the South closed, Baldwin kept hers open. Confederate money was of little or no value for tuition, so parents were given a choice of paying $1,400 cash or $67.50 in farm produce or even firewood.

After the war, Baldwin set about transforming the institution from a finishing school to a true place of learning. She believed that her "young ladies" should be able to study the same courses as those taught at the University of Virginia. In honor of her dedication and service of thirty-five years, the Virginia State Legislature and the board of trustees changed the name of the college to Mary Baldwin Seminary in 1895. Two years later, Miss Baldwin died and it was decided that her birthday was to be celebrated as Founder's Day. Mary Baldwin Seminary continued to operate under that name until 1923, when it was declared an accredited liberal arts college. At that time the name was changed to Mary Baldwin College. Today it is the oldest female academic institution in America associated with the Presbyterian Church.

Just past Mary Baldwin, turn north onto New Street and you pass into the Stuart Addition Historic District. In 1803, Judge Archibald Stuart gave about thirty acres of his land to the newly incorporated town. This neighborhood was ethnically diverse, and as such it has a unique character. It also has some of the oldest surviving structures in town.

On your left are a series of structures related to Saint Francis of Assisi Roman Catholic Church. A Catholic congregation was formed in 1841 and within eight years the first church was built on donated land. Shortly after the Civil War, the Saint Francis Academy opened at what is now 121 North Augusta Street. In 1878, the building was converted into a convent. The nuns are no longer there, but the structure continues to be used by the congregation. The present Gothic Revival church was built in 1895, based on a design by T.J. Collins.

Just past the church at 210 New Street is the C.W. Miller home. Designed by T.J. Collins in 1900, it is one of the finest Chateauesque structures in the area. It is also listed on the National Register.

Saint Francis Catholic Church was designed by T.J. Collins in 1895. *Courtesy of Historic Staunton Foundation.*

Across the street is the site of the Staunton Academy. Founded in 1792, it was one of the first schools in the Shenandoah Valley. It operated until 1873. The site is presently occupied by a Mary Baldwin dormitory, which was built in 1928.

Moving farther down New Street, there are a number of nice examples of late nineteenth- and early twentieth-century apartment buildings. Still farther you will find 401 and 425 New Street, which are two early nineteenth-century brick structures.

If you turn up Prospect Street and head up the hill you will enter the Mary Baldwin Campus. Look carefully at the gray walls and you will notice the letters "SMA." This was once part of the Staunton Military Academy. On your left at 119 Prospect is the office of Mary Baldwin's Adult Degree Program. In 1875, this was the home of Joseph Waddell. Waddell was born in Staunton in 1823. He published the *Staunton Spectator* and wrote a number of key histories of the area: *Annals of Augusta County, Home Scenes and Family Sketches* and *History of Mary Baldwin Seminary.* He was a member of the House of

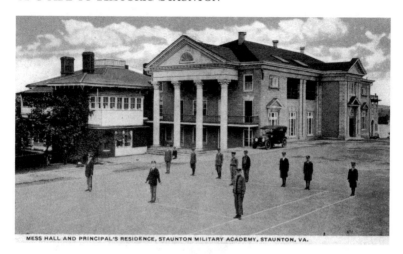

MESS HALL AND PRINCIPAL'S RESIDENCE, STAUNTON MILITARY ACADEMY, STAUNTON, VA.

The parade square of Staunton Military Academy around 1920. When Woodrow Wilson came to Staunton in 1912, he had his birthday dinner at the SMA Mess Hall. The structure in the center of this picture was designed by Collins and Sons in 1913. It replaced the building where Wilson dined. Despite this, there is still a star in the floor marking the spot where the president-elect ate. *Postcard from the collection of the author.*

Delegates, a state senator and clerk of the court of appeals. He was also responsible for hiring Mary Baldwin to run the Augusta Female Seminary. His diary is an invaluable source for local nineteenth-century history and is located in the Albert and Shirley Small Special Collections Library at the University of Virginia in Charlottesville.

Across the street is Kable House, named in honor of William Kable, founder of the Staunton Military Academy. Kable purchased the structure from J.W. Alby, who had built it in 1873. The origins of the academy go back to Charlestown Male Academy, founded by William Kable in 1860. Kable fought for the Confederacy, but returned to West Virginia to reopen his school after the Civil War. In 1883, he decided to move the educational institution to Staunton and three years later he introduced a cadet system and changed the name to Staunton Military Academy.

Walk a little farther down Prospect Street and then turn right up the service road. The parking lot is what used to be the center of the Staunton Military Academy. The school grew in size until

November 1904, when most of the buildings burned. The Kable family, however, refused to quit and by March 1905 the South Barracks had been rebuilt. During World War I, SMA became an official unit of the Junior Unit of the Reserve Officers' Training Corps Program. It survived the Great Depression and went on to become one of the country's most prestigious military academies.

One of the school's most famous teachers was Lieutenant General Alexander M. Patch Jr. After service in World War I, Patch, then a major, came to the Staunton Military Academy in 1920. He served as an instructor of military science and tactics until 1928. He returned from 1932 to 1936 when he was transferred to Fort Bragg. In August of 1941, he made brigadier general. In March of 1942, he was sent to the Pacific and placed in charge of Allied forces in New Caledonia. After serving on Guadalcanal, he was given command of the U.S. Seventh Army, which invaded southern France on August 15, 1944. At the end of the war, Patch captured Hermann Göring. He received a hero's welcome when he returned home on June 27, 1945.

Staunton Military Academy continued to grow through the 1950s, but attendance fell sharply during the Vietnam War. The Kable family sold the school in 1973. Three years later, it closed and Mary Baldwin College bought the property. The North and South Barracks are gone, but many of the other buildings remain. The college and the SMA Alumni Association have forged a strong relationship and the cadets of Mary Baldwin's Virginia Women's Institute for Leadership (VWIL) Color Guard carry Staunton Military Academy colors. VWIL was originally created by the Commonwealth of Virginia to provide an alternative for women so Virginia Military Institute (VMI) in Lexington would not have to become coed. The Supreme Court eventually forced VMI to admit women, but VWIL proved so successful that Mary Baldwin College elected to keep the program. VWIL cadets also help staff the SMA-VWIL Museum, which is located beneath the parking lot off Kable Street. Some of Staunton Military Academy's more famous alumni include Senator Barry Goldwater and World War II navy ace and Medal of Honor recipient David McCampbell.

Head out of the parking lot, through the Staunton Military Academy gates and down Kable Street to Coalter Street. In front

Up until the 1950s, much of Mary Baldwin College's campus would have been familiar to the lady for whom the institution takes its name. The college then began to grow up Frederick Street Hill, absorbing part of Market Street and the former King's Daughters Hospital.

of you is one of several Spanish Revival homes found throughout the city. It was designed by Sam Collins in 1926. At the junction of Coalter Street and Sherwood Avenue is the Grubert House, an Italianate structure built in 1877. Sherwood Avenue is a quiet little street filled with modest homes built around the turn of the century. The one exception is El Capote, a Tudor Revival home built for A. Erskine Miller in 1907. The house is named in honor of the ranch the Erskine family owned in Texas before the Civil War. The street takes its name from the home at 611 East Beverley Street. The structure was originally built in 1855 and at one point served as a Baptist school. At the end of the nineteenth century, the rear of the property was subdivided and by 1909 the street had gained its present name.

Take Coalter Street down the hill, turn right on Frederick Street and you are back downtown. The area of Mary Baldwin's campus on your right was a neighborhood of small homes until the mid-1960s. This was also the home of the local hospital, King's Daughters, from 1905 to 1951.

Downtown

Today, little remains of William Beverley's village, but much of what replaced it can still be found in downtown Staunton. The community first began to grow with the introduction of several major roadways. Next came institutions like Western State Hospital, the Virginia School for the Deaf and Blind, Mary Baldwin College and finally the railroad in 1854. The Civil War halted growth, but after the end of Reconstruction Staunton became a boomtown. A manifesto of this change took place in 1871 when Staunton was rechartered to become an independent city. Much of downtown's surviving core can be traced to the period between 1870 and 1910.

When you talk about Staunton and its architecture from this period, no discussion can take place without the name Thomas Jasper Collins. T.J. Collins came to Staunton in 1891 and before his retirement in 1911 he built or remodeled over two hundred structures in town. Collins was born in 1844. He served in the Civil War and had been an engineer and architect for the post office in Washington, D.C., before answering an advertisement for the position of draftsman at the Staunton Development Company. Like many communities in Virginia, the city was in the midst of a land boom fueled by Northern capital. Towns like Lynchburg and Buena Vista built luxury hotels to attract visitors who would then invest. Unfortunately, there were too many land schemes and not enough investors. When the stock market crashed in 1893, the situation worsened.

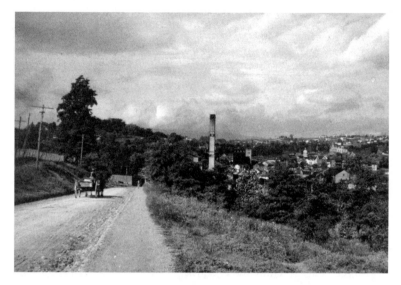

Traveling into Staunton from Route 250 (Richmond Road), you can still see much of the same view as this one taken in 1900. *Courtesy of the Hamrick Archives.*

After the Staunton Development Company folded, Collins could have returned to the nation's capital. Luckily for the city, he chose to stay. There appeared enough business, so he convinced another draftsman to form the firm of Collins and Hackett. Hackett left after a year, but Collins liked Staunton. His son William joined him and the firm was renamed T.J. Collins and Son. In 1905, another son, Sam, left an architectural practice in Raleigh, North Carolina, to join his father's firm. When T.J. Collins suffered a stroke in 1911, Sam took over the business. During his almost fifty-year career, Sam designed 137 houses, 60 churches, 19 schools, 42 two commercial buildings, 35 manufacturing structures, 4 banks, 7 civil buildings, 6 courthouses and city halls, 2 libraries and a hospital. In 1933, William left Staunton to work for the government, but he returned in 1946 to help his younger brother, whose health was failing. William died two months after Sam passed away in 1953. William's son, Richard, then ran the firm from 1953 until 1961, when he returned to Washington, D.C., to open his own firm and teach at Catholic University. Richard was in turn succeeded by his

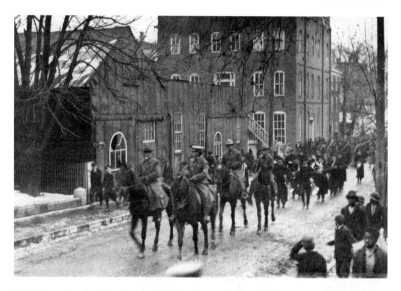

This is a view looking down Market Street from what is today Mary Baldwin College. The picture was taken of troops returning from the punitive expedition to Mexico in 1917. The lower wall on the far left belongs to the lot where the Temple House of Israel now stands. The buildings behind are the Hardy Carriage Works, which burned in the mid-1920s. *Courtesy of Historic Staunton Foundation.*

cousin and grandson of T.J. Collins, J. Joseph Johnson. Joe started working for the firm in 1950. He ran the firm until his retirement in 2006, at which time he donated the firm's drawings to the Historic Staunton Foundation.

For many, a visit to downtown Staunton begins by parking at the Hardy Lot. Until 1928, this was the site of the Hardy Carriage works. It was, however, not just an industrial site in the center of town. In 1865, former slaves and free blacks began meeting here for Sunday services. Each week, members brought dimes to go toward the purchase of land for a church. Today, that congregation meets at the United Methodist Church on North Augusta Street.

Head up Market Street; on your right is the American Shakespeare Center's Blackfriars Playhouse. In 1988, a professor at James Madison University formed a traveling troupe of players with the mission of bringing Shakespeare out of the classroom and back to the public. They found a permanent home in Staunton and in

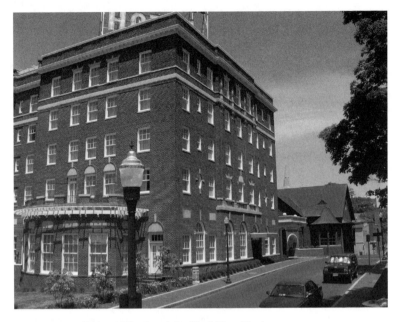

The Stonewall Jackson Hotel and the Blackfriars Playhouse.

2000 began construction on this building. Inside is a reconstruction of Shakespeare's 1614 Blackfriars Theater. They perform plays without modern stage lighting, using only the house lights, and regularly involve the audience in the production.

Next on the right is the new addition to the Stonewall Jackson Hotel, completed in 2005. When the hotel opened in 1925, it was the finest place to stay in Staunton. The structure was designed by the New York architectural firm H.L. Stevens and Company and cost $750,000 to build. Business was so good that the owner, Alexander T. Moore, opened a golf course north of town and bought and tore down the Virginia Hotel behind his property to expand the Stonewall Jackson. Instead, the Depression closed the hotel. It reopened, but by the 1990s it had become subsidized apartments. Early in the twenty-first century, the city formed a private-public partnership to restore and reopen the Stonewall Jackson. You can see the results—a beautifully renovated hotel and conference center.

Across the street is one of the oldest buildings in this region of the city. It is named Kalorama, which is Greek for "beautiful view." It was built about 1810 on the foundations of Sir William Beverley's 1738 home. It was a private home until the 1830s, when it became a girls' school. Later it served as a hotel and from 1940 until the 1970s it was the city's public library. Much of its present appearance reflects a 1968 renovation.

At the junction of Market and Kalorama Streets sits number 200. It is a very unimposing structure with a long history. Built in 1837, it served as a schoolhouse, a military school and a meeting-place for Confederate officers. In 1885, it became the home of the Temple House of Israel. The oak floor, shutters, stone steps at the entryway and metal shingle roof are original. On the roof, the large square patch shows where there was originally a belfry. According to temple history, the interior could hold forty to sixty people, depending on the arrangement of the pews.

Kalorama Street takes its name from the nearby home at 19 South Market Street. It was here that T.J. Collins began to make a name for himself in Staunton by designing number 215 in 1891 for the then–city treasurer, Arista Hoge.

Looking down Kalorama Street, you will immediately be struck by the house at 215. This brown stone structure was one of T.J. Collins's early commissions. It was designed for city treasurer and president of Thornrose Cemetery, Arista Hoge. Collins, or one of his sons, also designed a number of the other homes on this street. Turn around and head west back to the hotel and down the hill. Across Greenville Avenue is the White Star flour mill.

At the bottom of the hill is the New Street Parking Garage. Designed by Frazier and Associates at the turn of the twenty-first century, it is one of the few parking garages ever to win a preservation award. Staunton's famous parking lot stands on the site of the Virginia Hotel. Built in 1840, it replaced Washington Tavern, which hosted such famous people as Thomas Jefferson, Henry Clay, James Madison and Millard Fillmore. The Virginia served as Jackson's headquarters. By the early 1900s, the hotel had fallen on hard times. The owner of the Stonewall Jackson Hotel bought the building in 1924. He planned a $700,000 expansion

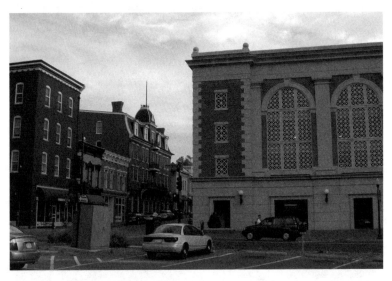

The building on the right is the New Street Parking Garage. The Eakleton Hotel was designed by T.J. Collins in 1894 in the French Second Empire style. It is the red brick building with the tower and flagpole. Woodrow Wilson stayed here in 1911.

to his hotel, but his timing was bad. The Virginia came down in October 1930. With the Depression, there was no need to expand. Instead of a grand hotel, the site became a gas station.

Across New Street is the R.R. Smith Center. Today it houses the Staunton Augusta Art Center (founded in 1962), the Augusta County Historical Society (founded in 1964) and the Historic Staunton Foundation (founded in 1971). In 1894, it was built in the Second Empire style and was known as the Eakleton Hotel. Woodrow Wilson stayed here in 1911 and locals like to say that it was here that he kicked off his presidential campaign. Unfortunately, by the 1990s, it was literally a shell of its former self. Abandoned and condemned, in another community it might have been torn down. Instead, Frazier and Associates designed a successful restoration and adaptive reuse.

Half a block west on Johnson Street is the Augusta County Courthouse. This is the fifth building on this site and it was designed by T.J. Collins in 1901. The demise of the previous courthouse actually sparked one of the earliest preservation controversies in Staunton. It was designed by Thomas Blackburn in 1836 and was very Jeffersonian in its form and proportions. Its supporters used this reasoning to defend its preservation, but they were eventually won over by the idea of progress. Behind the courthouse is a series of connected low structures known as Barrister's Row. At the time of the Civil War, these buildings held everything from lawyers' offices to saloons to keep court proceedings running smoothly.

Across the street from the Wharf is a series of late nineteenth-century storefronts. If you look up the Central Avenue toward East Beverley Street, you will see the rear of Worthington Hardware. When it was constructed in 1890, it was known as the Crowle Building. Look carefully and you will see that the bricks on the rear corner do not match the rest of the building.

On Monday, September 28, 1896, a hurricane struck the Virginia coast, moving from the east. Rain began falling in Staunton the next morning and grew heavier as the day progressed. Around 9:00 p.m., Lake Tams in Gypsy Hill Park broke its banks. Four million gallons of water poured down Central Avenue. The wave took out the waterworks and the electrical plant. It swept the coffins out of

STAUNTON, Va. Augusta County Court House.

Left: The present Augusta County Courthouse, designed by T.J. Collins in 1901. *Courtesy of Historic Staunton Foundation.*

Below: The fourth Augusta County Courthouse, designed by Thomas Blackburn and built in 1835–36. *Courtesy of the Hamrick Archives.*

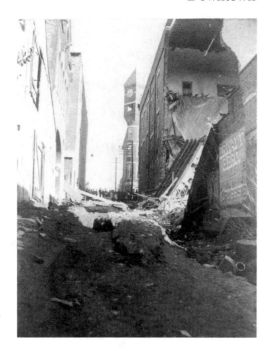

Looking at the rear of Worthington Hardware and the damage done by the 1896 flood. *Courtesy of the Hamrick Archives*

Hamrick's funeral home and knocked the back off of Worthington Hardware. It then washed away much of Johnson Street and the Wharf area. At that moment, the banks of the lake by the racetrack on Middlebrook Avenue gave way and the water washed down to the Wharf from the opposite direction. People watching a performance by Mademoiselle Rhea were trapped in the city opera house. The rain did not stop until 11:00 p.m. that night. Much of the wreckage collected around the C&O arched bridge. Six people and twenty-seven horses were killed, and twenty-five homes swept away. Today, the Worthington Hardware building would be condemned and torn down, but in 1896 they just repaired the structure.

Next to the Wharf parking lot is a 1910 commercial grocer's warehouse, which looks like a small daylight factory. The rear of the building employs a steel structure to let in as much light as possible and thus save on lighting bills. In the 1920s and 1930s, this type of practical design became the inspiration for avant-garde architects who would go on to build the skyscrapers of the 1950s

95

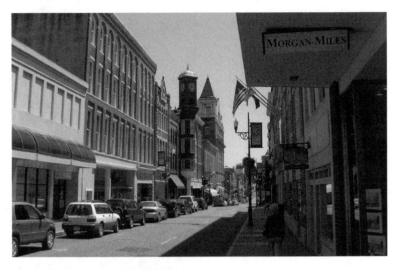

Downtown Staunton looking east from Lewis Street.

and 1960s. The batten board house at the corner of Johnson and Lewis Streets is not only a world away from the skyscraper, but also somewhat out of place in this part of Staunton. Built in 1854, it is thought to be the oldest unaltered structure in downtown. Below it at 109–111 South Lewis Street is the home of what was Dr. S.P. Hite's patent medicine factory. Hite came to Staunton in 1887 with a "Pain Cure" that could solve everything from headaches to gangrene. Business was so good that in 1893 he expanded and built this building. In 1905, Theodore Roosevelt signed the Pure Food and Drug Act and put Dr. Hite out of business.

Moving back up Lewis Street, you cross Johnson Street and walk pass the Lewis Street Parking Garage. At the turn of the twentieth century, this was the site of the Brethren Church. In June 1911, an unexpected tornado destroyed the church's roof. At the top of the street, head east down West Beverley.

Today's Staunton City Hall was a Leggett's Department Store up until the early 1990s. It now houses the oldest city manager–styled government in the country. By 1906, the Staunton population was over eight thousand. In reaction, the city created a bicameral government with eight aldermen and fourteen councilmen. There

was also a series of standing committees. Within a year, it was clear that such a system was too complicated for a city of Staunton's size. Finally, Common Councilman John Crosby suggested hiring a city manager to run the day-to-day business, with an elected council of five to oversee him and make laws. The city hired Charles E. Ashburner from Richmond in 1908. He had been born in India to British missionaries, studied in France and Germany and worked as a civil engineer for the Chesapeake & Ohio Railroad. In 1911, he was replaced by his assistant, S.D. Holsinger, who demonstrated to the people of Staunton that having a city manager was an effective way to run a local government. Ashburner left Staunton to work for the Lynchburg Traction and Light Company, but he remained committed to civic reform. Ashburner went on to found the International City Managers' Association in 1914. He worked as a city manager throughout the country until he retired in 1929.

In 1894, W.W. Putnam of Vermont moved to Staunton to make organs. At first, he rented a room at the YMCA. Business was so good, however, that two years later he opened a factory on the east side of town. At the same time, he purchased 103 West Beverley to serve as the showroom for the Putnam Organ Works. This building is a Romanesque Revival structure that at one time had a stone arch spanning the entire width of the street-level entrance.

Across from Worthington Hardware is one of Staunton's architectural landmarks: the Clock Tower Building. The structure was the second home of the city's Young Men's Christian Association and was built in 1890. In 1874, Staunton was the third city in Virginia, behind the state capital, Richmond, to have a YMCA. Three years later, the organization opened its library to women, thus allowing the city to say it had a public library. The structure at 27 West Beverley Street remained the home of the group until 1914, when it moved to North Augusta Street. Just up from the Clock Tower in Central Avenue is the home of the *Daily News Leader*. In 1919, future Brigadier General E. Walton Opie merged the *Daily News* and the *Evening Leader* to form a single local paper. Back on West Beverley Street, the next major structure is the Italianate Gooch & Hoge building. Designed in 1880, it is a typical late Victorian commercial structure.

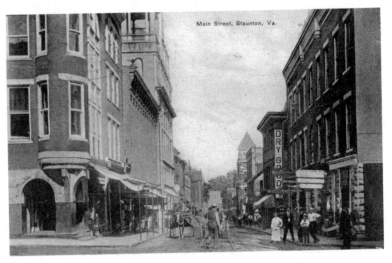

Downtown Staunton looking east, 1900. *Courtesy of the Hamrick Archives.*

The Masonic Building at 7–13 West Beverley Street was the tallest structure in Staunton when it was completed in 1896. Designed by Chicago architect I.E.A. Rose, it was the first building in Staunton to be completely electrified and the first to have an elevator. It was also connected to services from the Staunton Mutual Telephone Company, which had only opened the year before, costing fifteen to twenty dollars a year at the time. For local Masons, the location had special significance. When it was founded in 1786, Staunton's lodge was the thirteenth in the state. Early members include Meriwether Lewis, who together with William Clark was sent by Thomas Jefferson to explore the Louisiana Purchase in 1804. This structure replaced a lodge designed by Thomas Blackburn in 1852. Today the Masons meet just past Gypsy Hill Park in a more modern facility. Lang Jewelers, one of the businesses in the Masonic Building, still has its original display cases.

Across the street from the Masonic Building is 16 West Beverley Street. This housed the Haines family cigar factory on the second floor. William Haines left Staunton in 1914 for New York and then went on to Hollywood and became a silent movie star. He was the first MGM star to speak on film in 1930, but he soon left the movies

to become one of the top interior designers of the time period. He died in 1973.

The next structure is the National Valley Bank Building, designed by T.J. Collins in 1903. General John Echols started the bank in 1865. After the war, there was no capital in the area to begin rebuilding. Echols went to Baltimore, Maryland, and negotiated with then well-known philanthropist Enoch Pratt, who gave him $50,000 to start the institution. His son became bank president, built Oakdene and helped finance the Staunton Development Corporation. Collins's Beaux-Arts design is not only impressive from the outside. The interior is one of the most magnificent downtown. It features a large, oval stained-glass skylight. Much of the furnishings are also original. The Trust Department next door is a 1920s addition by Sam Collins. It contains a small museum about the bank's history and a large portrait of Woodrow Wilson signing the Federal Reserve Act, on loan from the Woodrow Wilson Presidential Library.

The National Valley Bank, designed by T.J. Collins in 1903.

The corner of North Augusta and Frederick Streets. The building on the right is the YMCA, built in 1914. It now houses condominiums.

If you look up North Augusta Street you will see Visulite Theatre on your left and the old YMCA on your right. The Visulite came to Staunton in the 1930s, but was an abandoned church by the end of the century. It has recently been restored and shows limited-run, art and foreign films. The YMCA is a Renaissance Revival structure that was built in 1914 at a cost of $100,000. Half of the money came from the estate of Cyrus McCormick, inventor of the reaper, whose farm is located south of Staunton.

Across the street from the National Valley Bank Building is the Marquis Building. T.J. Collins designed this Romanesque Revival structure in 1895 for Captain J.C. Marquis. Collins also had his offices on the third floor. The umbrella has become a fixture of Staunton, but when it was installed the city insisted that it violated its sign ordinance. The owner countered that it was not a sign because it had no words, and he won. The next two blocks are made up of small commercial structures built over a ninety-year time span. Numbers 6, 26, 28, 30–34, 112–118 and 128–130 East Beverley Street were all built between 1830 and 1850. When you consider that all these survived an occupation by the Union army, this is even more impressive.

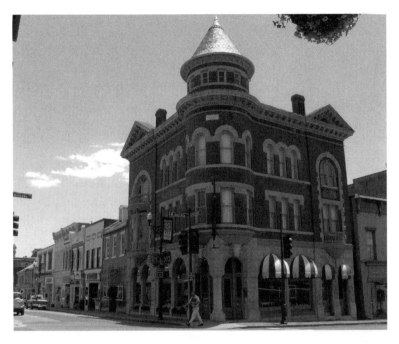

The Marquis Building was built by T.J. Collins in 1895 and housed his offices. It is a Romanesque Revival structure.

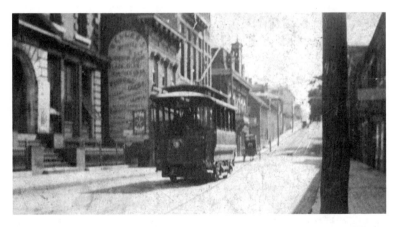

The streetcars originally ran from the Virginia School for the Deaf and Blind down Beverley Street to the train station. By the 1920s, according to longtime resident Francisco Newman, it cost six cents a ride or a quarter to travel all the expanded routes that ran throughout the downtown. *Courtesy of Historic Staunton Foundation.*

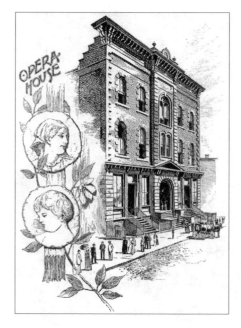

Staunton City Hall started life as the Grange Hall in 1870. Eight years later, the city purchased it and turned it into an opera house. The present façade was designed by Sam Collins around 1930. *Courtesy of Historic Staunton Foundation.*

Most of the buildings on the north side of East Beverley are younger. Two commercial structures that really stand out are the Wholey Building at 7 East Beverley and number 19–21. In 1899, T.J. Collins designed Mr. Wholey's façade to look like a miniature fourteenth-century Venican palazzo. Twelve years later, Mr. Switzer had Venetian Renaissance Revival white terra cotta panels applied to the front of his jewelry store. They were shipped from New York at a cost of $825.

The last block before Market Street has three interesting buildings. The first is the Staunton City Courthouse. The Grange Society built it in 1870. Eight years later, the city purchased the structure and converted it into municipal offices and an eight-hundred-seat opera house. The opera house closed in 1926, perhaps due to the popularity of the nearby New Theatre, and it became the city hall. About that time, Staunton adopted the motto "Moderata Durant," or moderation endures. Sam Collins remodeled the front façade in the mid-1930s. One building over is the Odd Fellows Hall, which was built around 1894 in the Chateauesque style. In the twentieth

century most of the decoration was removed and replaced with fake half-timbers to make it look Tudor. Finally, there is the Dixie Theater. Originally known as the New Theatre, it was designed by the Collins firm in 1912. It was an Italian Renaissance Revival structure that could seat twelve hundred with a very ornate interior. The theatre was a featured stop on the vaudeville circuit and was one of the first Virginia theatres to be wired for sound after Warner Brothers introduced talking pictures in 1927. A fire in 1936 destroyed the interior and the fly tower in the rear. John Eberson, who designed the Loew's Theater in Richmond, transformed the interior of what was then known as the Dixie into something very modern. The movie house has since been subdivided, but you can still see some of Eberson's work. The Staunton Performing Arts Center now owns the Dixie and plans are underway to restore it. Having gone through downtown Staunton, there is one Victorian element yet to explore: Gypsy Hill Park.

The Dixie Theater, Odd Fellows Hall (proposed home of the Staunton Performing Arts Center) and the city courthouse.

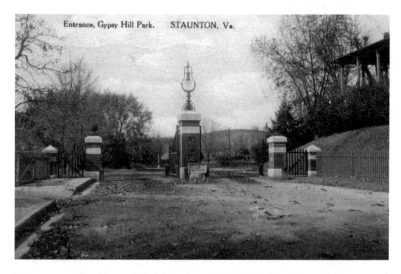

Entrance, Gypsy Hill Park. STAUNTON, Va.

The entrance to Gypsy Hill Park, circa 1908. Little has changed in over one hundred years. *Postcard from the collection of the author.*

By the end of the nineteenth century, city promoters began to refer to Staunton as the "Queen City." If the name is apt, then one of the many jewels in her crown would be Gypsy Hill Park. The land for the park was purchased from the Donaghe estate in 1876. Originally, the thirty acres were meant to serve only as a reservoir for the city's water supply. Over time the city purchased more land until by 1889 it had acquired eighty-nine acres. At that point, Captain William Purviance Tams convinced city fathers to turn it into a park. With their approval, in 1890 he began to landscape the space. Today, it still has a late Victorian appearance.

You can reach Gypsy Hill Park from two directions. If you take Frederick to Beverley Street to Thornrose Avenue you will access the side of the park with a golf course, the National Guard Armory and the home of the Staunton Braves. The armory houses the museum for the 116th Regiment of the 29th Division, which is open by appointment. They can trace their history back to 1741, but the 116th is most famous for its assault of Omaha Beach on D-Day during World War II. The building is dedicated to Staunton Military Academy teacher Thomas D. Howe. He is more commonly known

as the Major of St. Lo. He was killed during the taking of this French town in July 1944 and his men had his body placed there after its capture.

The Staunton Braves are part of the Valley League, made up of college baseball players. Games begin in early June and run through the end of July. The other way to reach the park is by taking North Augusta Street to Churchville Avenue. Here you will find playgrounds, a duck pond, little league fields, a swimming pool and a miniature train. Winding its way through this part of Gypsy Hill is a road accessible to cars, on which the Fourth of July parade is always held.

At almost the end of the drive through the park you will find a bandstand that owes its existence to the oldest continuously performing community band in the country. Professor Augustus J. Turner formed the Staunton Mountain Sax Horn Band in 1855 and it had its first public concert two years later. The band played for Presidents Millard Fillmore and Franklin Pierce. When the

The Bandstand at Gypsy Hill was built in 1976.

Commonwealth reorganized the militia, it became Staunton's band. In 1860, it performed for both the Southern Democrat John Breckinridge and Northern Democrat Stephen Douglas. With secession in 1861, the band members became part of Company L of the Fifth Virginia Volunteer Infantry Regiment within Stonewall Jackson's First Brigade. They not only played music but also served as stretcher bearers and couriers and performed guard duty. One member was killed, another was taken prisoner and several were wounded.

On June 30, 1874, President Grant passed through town on his way to White Sulfur Spring, West Virginia. Legend has it that as he reviewed the band from the balcony of the American Hotel it was referred to as the Stonewall Jackson Brigade Band. Whether the story is true, the name stuck. It played at Grant's funeral procession and the dedication of his tomb. The band has also performed for President Harrison and in the inaugurals for Cleveland, McKinley, Taft and Staunton's favorite son, Woodrow Wilson. On November 1, 1889, the Brigade Band played its first concert in Gypsy Hill Park and it has remained there ever since, with regularly scheduled performances.

In addition to the band, there are a number of events held at the bandstand during the summer. In 1988, Staunton began hosting "Jazz in the Park" on Thursday nights. There is also gospel music and old movie nights. In September, Gypsy Hill hosts an African American festival and from Thanksgiving until New Year's there are festival lights at night. Few people outside of Augusta County know that Anna Mary Robertson (Grandma) Moses, the famous primitive painter, lived in several locations around Staunton between 1886 and 1905. One home is located on the property of the Augusta County Government Center in Verona. In 1901, her canned fruit won first prize at the county fair then held in Gypsy Hill Park. One of her earliest works is a painting of the park.

A Different Perspective

O ne of the many myths of the Shenandoah Valley is that slavery never took root here in the same way it did in eastern Virginia or in the Deep South. Nineteenth-century historians of the area Joseph Waddell and John Wayland promoted the concept that the Scotch-Irish were adverse to bondage. While there were not great plantations in Augusta County, this still left the door open to small farmers and merchants who might own one to five slaves. To get a sense of how early slavery and free blacks arrived in Augusta County, one need only to look at court records. The year 1745 marked not only the county's founding, but also the listing of the first runaway slave. Four years later, Christopher Roarrey, then a child, became the first free black listed in Augusta County.

One of the most common practices in the valley was to hire out your extra slaves. African Americans could gain new skills that made them more valuable. The master made money on the deal and had one less mouth to feed on the farm. Slaves were usually hired out for fifty-one weeks of the year. From Christmas to New Year's, they were allowed to return home to see their families and prepare for the next hiring season. It is impossible to completely understand the strain this placed on a family, but it was perceived at the time as being better than being sold down South. There was a well-known slave merchant in Harrisonburg who often "shipped" slaves South in the fall in groups chained together.

The first federal census in 1790 recorded that Augusta County was 14.4 percent black and that 96 percent of these individuals were slaves. Between 1790 and 1860, the black population grew by 276 percent, while the white population increased by only 132.65 percent. As early as 1800, one quarter of Staunton's population was African American. Many of these men and women were owned by 22 percent of the white population. By 1850, the amount of slave owners had risen to 30.2 percent. The free black population grew in Augusta County until Nat Turner's rebellion in 1831. Afterward, the state did its best to encourage them to leave.

The life of a freed black was rarely easy during the first half of the nineteenth century. Starting in 1810, the state required them to register at the courthouse. Historians suspect that only one-third actually did. By 1860, there were 586 recorded free blacks living in Augusta County and 106 in Staunton. Most worked as laborers, but a small number were seamstresses, coopers, carpenters, blacksmiths and shoemakers. There were a few, however, who made a success of the system. When barber Robert Campbell died, the buildings he owned on the corner of New and Beverley Streets were worth a total of $6,000. He was so popular within the white community that the Southern-leaning Democratic paper ran his obituary, a very rare mark of respect. As a barber, Campbell was seen as nonthreatening and at the same time he benefited from the information that his clients divulged while they had their hair cut.

Before the Civil War, religion was the one area where African Americans could express some choice. When the Baptists formed their first congregation in the early 1850s, forty of the sixty-nine members of the church were black. They not only attended the segregated white services but also held their own. These were often led by Ben Downey and Laura Campbell. Many blacks worshiped at the Lutheran church located where the Clock Tower Building is now. In 1850, roughly two hundred of those who attended Central United Methodist were African American.

Freedom brought with it a desire to worship independently of whites. In 1865, former slaves founded the Allen Chapel. The oldest black church west of the Blue Ridge, it is named for Richard Allen (1760–1831), who founded the African Episcopal Church in 1816.

Allen Chapel, the oldest African American church west of the Blue Ridge Mountains. *Courtesy of Historic Staunton Foundation.*

In November of that year, the Reverend Jacqueline Strange and twenty members purchased a lot at 921 West Beverley Street and construction began two years later. While they waited for the church to be completed, the congregation met in the Lutheran church. They also opened the first black school in the city. The building was renovated in the first decade of the twentieth century and the present façade was completed in 1924. The congregation moved to 936 Sudbury Street in 1997, but the original structure is still standing.

The Augusta Street United Methodist Church was the next congregation to be formed. Known as the "ten-cent church," the members first met at Hardy's Carriage Works (now the city lot on the corner of Market and Beverley Streets). They gained their name by their fundraising technique of seeking small donations. Within a year, enough money was raised to purchase a site and in 1869 construction began on the church itself. It was a one-story board and batten style and was used as the black public school from 1872 to 1876. The present structure was built in 1876. In 1911, T.J.

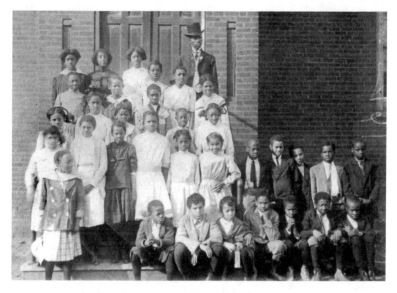

George Ambrose Newman Jr. with his students at the Fairview School during the first decade of the twentieth century. Professor Newman specialized in music and penmanship, but like many African American educators of the time he was called on to teach everything from kindergarten to college preparatory courses. *Courtesy of Mrs. George Newman.*

Collins and Son renovated the building with a new façade, steeple and extension.

In 1868, the black Baptists asked to leave the white First Baptist Church. The congregation responded by lending them $500. The new Mount Zion Baptist Church bought a cabin on Frederick Street, but within two years moved to Sunnyside Street. While there, the church split. In 1878, a group met at the home of Deacon Henry Burke. By the end of the year, they had found an old Methodist church to use and had received the blessing of the First Baptist Church to call themselves Ebenezer Baptist. In 1904, Mount Zion moved to Augusta Street, just a block north from their younger sister. Mount Zion then hired T.J. Collins to design its present structure. Ebenezer had also contracted with Collins in 1900 for a design, but when it came time to build in 1910 they rejected his Palladian façade for something more traditional.

The use of both Allen Chapel and Mount Zion as schools reflected a pattern of blacks utilizing whatever space was available in order to provide their children with a good education. From 1872 until 1876, the public school was held at the Augusta Street Methodist Church. Afterward, it moved to a variety of commercial buildings, including the Timberlake Tobacco Factory. Most whites tried to ignore the issue of African American schools until 1883. Local black leaders pushed the school board to provide properly educated teachers. When the effort failed, they created a Colored Teacher's Institute, which trained a total of forty-four teachers. By 1915, there were two truly public black schools: D. Webster Davis on Johnson Street and Booker T. Washington on Sunnyside Street. There were two schools in part because of rivalries between African Americans living west of Newtown and those living near the Stuart Addition. The first Booker T. Washington School still stands. African Americans, however, were not allowed to graduate with an accredited high school diploma until 1926.

Despite segregation and neglect, by the 1920s, the African American community of Staunton had created a corridor of black-owned businesses along Sunnyside, Augusta and some sections of Frederick and Beverley Streets. Some were clearly commercial while others were run out of people's homes.

The area around Baptist Street and Sunnyside had a number of shops and at least one grocer, but the two most important places were (1) Booker T. Washington School and (2) the Palace Auditorium. The Palace was originally the second home of Mount Zion Baptist Church. According to Thomas Burress, who grew up in segregated Staunton, it provided one of the few social venues outside of church and the pool hall.

Moving south on Augusta there were several tourist homes. Dr. Pannell ran one at 613 North Augusta Street (3) and the Ware family ran another at 401 North Augusta Street (4). During segregation, local hotels would not serve black customers. Professor Ware also had a music studio while his wife ran a beauty salon. Today, their home is one of the oldest structures left in Staunton.

Right before you get to Ebenezer Baptist Church, 501 North Augusta (5) was home to both the North Carolina Mutual

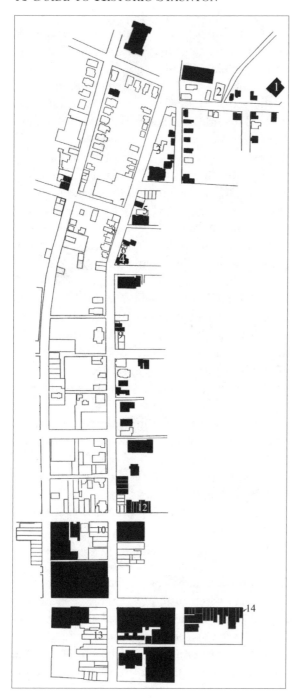

This is a map
of structures
present in the
North Augusta
Street–Central
Avenue Corridor,
which was targeted
for urban renewal.
The buildings in
black still exist.
The numbers
refer to some
of the African
Americans that
were in business in
Staunton in 1925,
based on research
by Francisco
B. Newman Sr.
*Courtesy of the
author.*

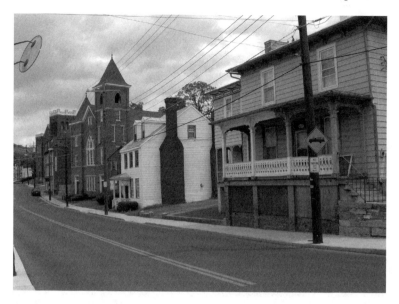

The building in the foreground (401 North Augusta Street) dates to about 1810 and perhaps was originally a log structure. The next structure (409 North Augusta Street) is also from about 1810 and is a log structure beneath the modern cladding. The churches behind it are Augusta Street United Methodist, Ebenezer Baptist and Mount Zion Baptist.

Life Insurance Company and the *Staunton Tribune*, a black-run newspaper. There was also another insurance company at number 407 (6). Across the street, where the fire station parking lot is now, was Johnson's Restaurant (7). Number 412 North Augusta (8) was the Peoples Drug Store and a meeting place for the Chisolet Club. Finally, Frank Evans ran a barbershop at number 307 (9).

The area around the junction of Frederick and Augusta Streets had a number of African American businesses. There was Jones Meat Market at 40 North Augusta (10); Knox Shoe Repair at 3 East Frederick (11); the Peoples Dime Savings Bank & Trust and Dr. Scott, MD, at 19 East Frederick (12); and the Southern Aid Society of Virginia next door. This is just a sampling of some of the businesses and where they were located. African Americans in Staunton also had their own tailor (13), dentists, a lawyer with an office at 111 South Augusta Street and a jeweler. The Prince Hall

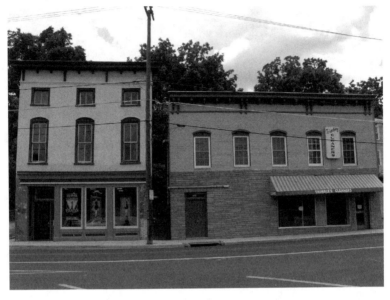

In 1925, the building on the right was Luther Howard's restaurant. Today it is one of the few historic commercial structures on North Augusta.

Masonic Lodge (14), which still exists on the corner of Beverley and Market Streets, was one of the oldest in the state.

The Depression hurt this thriving community. Institutes like the Dime Savings Bank closed in 1931, but many of the core businesses survived into the late 1950s. What the economy could not destroy, urban renewal would. Since the end of World War II, Staunton had witnessed a decline in business. The solution was a master plan for development that was released in 1959. It called for the renewal of the downtown, which would involve the bulldozing of much of the downtown's core. Beautiful plans were released by the Staunton Housing and Development Authority showing a bright and shining city. They promised that a new shopping area would increase the tax base. The test area was to be the largely African American business district and the federal government would cover up to three-quarters of the $1.2 million for the project.

On October 17, 1962, council voted four to one in favor of the plan. The one dissenting vote was Dr. Patricia Menk, history professor at

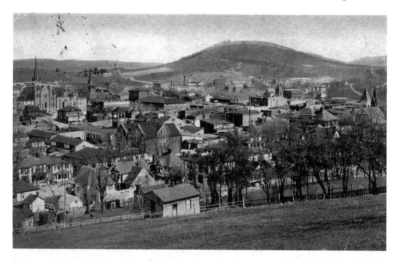

Postcard from the collection of the author.

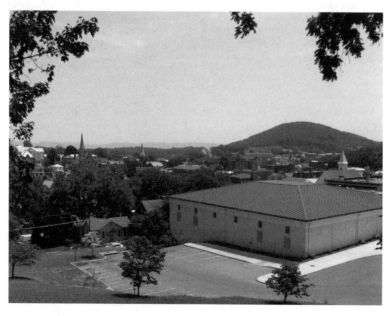

These two views of the Central Avenue corridor were taken from the same spot just above Stuart Hall. The first dates from the early twentieth century and clearly shows the vitality of an area that was dominated by African-American businesses. Today, trees hide the blight left by urban renewal.

115

This picture was taken shortly before this bakery was condemned for urban renewal. Only Saint Francis Catholic Church, in the background, still exists. *Courtesy of Historic Staunton Foundation.*

Mary Baldwin College and later the first female mayor of the city. What some saw as a blighted area included thirty-buildings housing twenty-six businesses and seventeen families. With the help of the Virginia Retail Merchants Association, they fought the demolition order in court but lost. To make matters worse, council failed to coordinate with Washington and lost federal funding. By 1966, they had taken a vibrant business community and turned it into a giant parking lot. Instead of paying city taxes, thirty-eight retailers chose to build what is now the mall outside the city limits in the county. With the exception of the firehouse, which houses Staunton's first motorized fire engine, "Jumbo," the area has never recovered.

Just to the west of Newtown on Johnson Street is the Booker T. Washington Community Center. It was one of the bright stops to come out of the Depression for the city's African Americans. Construction of the building began in 1936, under the Public

The Elks Building, while on the edge of the urban renewal corridor, was not affected. *Courtesy of Historic Staunton Foundation.*

Works Administration Project VA. As part of Franklin Roosevelt's New Deal, the PWA had a mandate to invest 10 percent of its projects on minorities. For the first time, Staunton's black students had a modern high school that could accommodate one hundred pupils. The school opened the following year and drew students not only from the city but also Augusta County and the Rosenwald area of Waynesboro. Throughout its twenty-nine-year history, it became well-known throughout the state for its band, athletics and high academic standards.

One of the most famous students of the school was Captain William W. Green. After graduating in 1939, Green spent two years at A&T College in Greensboro, North Carolina, where he joined the Civilian Pilot Training Program. From there he entered the Aviation Cadet Program at Tuskegee, Alabama, in 1942. He graduated in 1943 as a second lieutenant and fighter pilot assigned to the Ninety-ninth Pursuit Squadron, which was the first all-black fighter squadron in American history. A Tuskegee airman, Green was shot down over Yugoslavia and fought behind enemy lines with the freedom fighters of that nation. For his valor he was awarded

117

Booker T. Washington High School.

the Order of the Partisan Star, Third Class, Yugoslavia's award for bravery. After the U.S. Air Force integrated in 1948, he went on to fight in Korea. In 1999, the Staunton City Council approved the creation of a memorial in his honor at the National Guard Armory in Gypsy Hill Park.

Another important graduate was Arthur R. Ware Jr. A native of Staunton, he returned to teach mathematics from 1933 to 1941. In 1950, he was made principal of Booker T. Washington High School and after the school closed he became Staunton's director of adult education and administrator of federal programs for Staunton city schools. On June 7, 1979, the school board renamed Westside Elementary School in his honor.

Staunton had a long record of ignoring black education. After the Supreme Court case of *Brown v. Board of Education*, the city sought to buy time by upgrading facilities and building four new classrooms at Booker T. Washington High School. Four more were added in 1963, but it did not satisfy the African American community. In August 1963 they petitioned council: to give blacks equal access

to all public accommodations; for the creation of an ordinance to bring about equal opportunity in hiring within city government, business, industry and the public utilities; and for creation of a plan to speed up desegregation of the school system. Black leaders also wanted the abolition of illegal housing restrictions and the right to bring other racial grievances before council or the Community Relations Committee. The movement was lead by the Staunton chapter of the NAACP, which had been organized in 1948 by the Reverend T.J. Jemison of Mount Zion Baptist Church. In the 1950s, they sued the police force for brutality, but there had been no violent protests in the city. Council therefore forwarded the petition on to the Staunton Community Commission. In turn, the commission contacted the Chamber of Commerce. In response, most businesses and all but one restaurant were willing to integrate to avoid trouble. The one holdout was the school board. They only agreed to integrate the school system after the NAACP sued them. A plan was initiated and all black schools closed in 1967.

For many growing up in Staunton in the early twentieth century, segregation was something subtle. African American parents tried to shield their children from its effects. But there was one place where racism was clearly evident: Gypsy Hill Park. The facility was white-only for all but one day a year. To add insult to injury, after the day when African Americans were allowed in the park, the pool would be drained and completely cleaned before whites were allowed to use it again. After World War II, black leaders pressured the city to open the park to African Americans on a regular basis. Instead the city purchased 150 acres of John Howe Payton's estate for $42,500 to serve as a park for the black community.

Peyton was a Princeton graduate who moved to Staunton in 1808. He named the estate after his wife, Ann Lewis Montgomery. She was the great-granddaughter of John Lewis. They had ten children and entertained such notables as Henry Clay, who authored both the Compromise of 1820 and the Compromise of 1850. Peyton was the Commonwealth's attorney for Augusta County for thirty-two years and served in the War of 1812 under General Robert Porterfield. He helped found VMI, was mayor of Staunton twice and also served as a congressman.

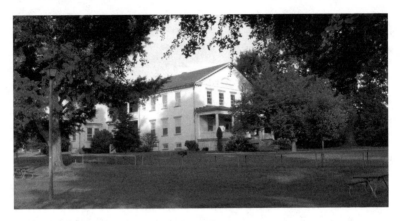

Montgomery Hall Park.

At first, the black community was thrilled, and then the city council informed them that they would be responsible for furnishing and maintaining the facility. The Reverend T.J. Jemison of Mount Zion Baptist Church, who pressured the city, formed a Park Committee to oversee operations. Over the next year, the committee solicited donations from both black and white businesses and the park opened on time on July 4, 1947. The mansion had tennis courts, a bowling alley, game rooms, a baseball field and a dance hall. It also had a meeting place for clubs like the Daughters of Ethiopia, the Matron's Progressive Club, the Sunshine Circle, the Girl Scouts and VFW Post 7814 Thomas and Fields (named for two local blacks who died in World War II). In 1952, Elizabeth Catlett left $10,000, which her sister gave to the Park Committee for a pool. For many, the park replaced the church social hall as the center of the city's black community. It was not, however, just for Staunton. As one of only two "Negro" parks in the state, Montgomery Hall attracted people from all over.

Expenses were always tight, but the Park Committee successfully oversaw Montgomery Hall until the city fully integrated in 1969. Almost immediately, the park began to deteriorate. Finally, the Booker T. Washington High School Alumni Committee pressured the city in 1974 to invest in the facility. Today, it is a hidden jewel within the community, actively used by families and children from all parts of the city.

Turning Things Around

In 1970, a group of concerned citizens met to discuss Staunton's past and how little of it might be left for the future. Despite the failure of urban renewal along North Augusta Street and Central Avenue, there were those who felt that Staunton could only attract needed development by tearing down more old structures to start fresh and build anew. Those at this meeting, however, believed that the city's lack of economic growth in the late 1950s and 1960s might work to the community's advantage. They were bolstered in belief by Calder Loth of the Virginia Historic Landmarks Commission. Loth had put a number of local buildings—including Wilson's Birthplace, Trinity Church and the Stuart House—on the National Register of Historic places. Like the Reverend Goodwin, who had recognized the colonial architectural heritage in Williamsburg, Loth saw a nineteenth-century city beneath aluminum cladding and plywood storefronts.

The Historical Staunton Foundation was founded in May 1971 and within a year faced its first major challenge. In 1972, the Virginia Department of Transportation (VDOT) announced a plan to widen Middlebrook Avenue by removing the Wharf and the American Hotel. With Loth's help, the foundation began meeting with city officials. The key factor was whether the Wharf could be economically viable. There were those in the community who accepted that buildings like Trinity should be

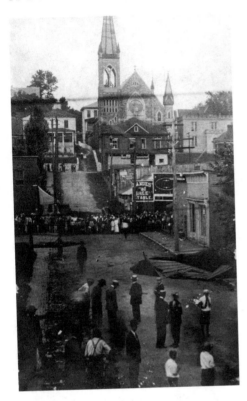

On August 11, 1910, three sinkholes opened up around Baldwin and Lewis Streets. The one pictured threatened to take down the firehouse. They had been caused by redirecting an underground stream. The firehouse had to be burned down and was replaced with a similar structure in 1912, which still stands. *Courtesy of Historic Staunton Foundation.*

saved, but to them the area around the train station was filled with "mongrel" architecture. While the debate raged, a small amount of investment began to take place around the Wharf. Local potter Jim Hanger was rehabbing the Witz factory building to use as both his home and a studio when he was asked if he would be willing to rent commercial space. Not wishing to kill another business area that was starting to show potential, council tabled the VDOT proposal.

The next challenge Staunton's council offered preservationists involved Barnas Sears's home. The property had been given to the city back in 1928, but by 1968 it was all but abandoned and no one remembered Sears or what he had done for the South. Historic Staunton secured a matching grant of $20,000 in early 1974. The city responded by selling the property, luckily to the Reverend

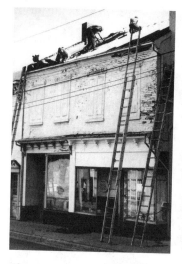

Courtesy of Historic Staunton Foundation.

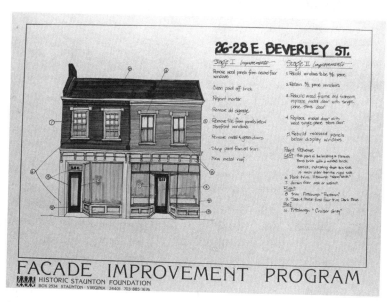

Courtesy of Historic Staunton Foundation.

These three images provide an excellent example of how historic Staunton's façade improvement program changed the look of a structure for little upfront cost.

In 1986, the Historic Staunton Foundation introduced guided walking tours, which are offered every Saturday from May through October. *Courtesy of Historic Staunton Foundation.*

Woodward Morris Jr., who was president of the committee to save the home. Its restoration was completed in 1978 and celebrated by an open house that included local country musical group the Statler Brothers.

In 1978, Historic Staunton, under the leadership of Kathy Frazier, introduced its very successful façade improvement program. The foundation provides free advice to business owners looking to bring character back to their historic commercial space. Owners discovered that by removing plywood over windows and using period-correct colors they could increase their business, and over time this has transformed downtown Staunton. By 1988, the city recognized that there was a profit in preservation and passed an anti-demolition ordinance. While Historic Staunton led many of the early fights, downtown Staunton's present appearance would not exist without broad community support.

Wright's Dairy Rite has been a local institution since the 1950s. Its onion rings are famous.

The English farm at Frontier Culture. *Courtesy of Museum of Frontier Culture.*

In the 1950s, people passing through Staunton stopped at Woodrow Wilson's Birthplace, had lunch at Mrs. Rowes' Restaurant or Wright's Drive-in and that was it. Today, while all three of these local institutions still exist and are worth visiting, there are a variety of new historic and cultural activities in and around Staunton. Between downtown and the interstate is the Frontier Culture Museum. A private-public partnership, it grew out of a desire to learn how and why America's first frontier in Augusta County developed the way it did. Frontier Culture is an outdoor, living history museum and educational institution that currently features six permanent, outdoor exhibits composed of original farm buildings from Ireland, Britain, Germany, Africa and Virginia. These buildings were carefully documented, dismantled, transported to Staunton and restored. The facility is presently in an expansion phase.

In addition to the American Shakespeare Center, the Oak Grove Theater is a hidden gem just north of town in Verona. Started over fifty-five years ago, the troupe performs five plays all summer

Created during the Great Depression, the Skyline Drive gives motorists the opportunity to see the landscape of the Shenandoah Valley, which captured the imagination of early explorers.

Not every home in Staunton was built before 1925. If you know where to look, you can find little gems like this International-style structure. *Courtesy of Historic Staunton Foundation.*

long in an outdoor theater under a grove of oak trees. Just east of Staunton is Fishersville, which has Barren Ridge Vineyards and the Andre Viette Farm and Nursery, which host the Day Lily Festival every July. Waynesboro, ten miles to the east, has the Waynesboro Heritage Museum and a museum dedicated to nationally known artist P. Buckley Moss. Finally, to fully appreciate what John Lederer and Governor Spotswood saw when they first set their eyes on the Shenandoah Valley, drive past Waynesboro and enjoy the breathtaking views of either the Skyline Drive or the Blue Ridge Parkway.

Visit us at
www.historypress.net